IMAGES of America
THE UPPER PERKIOMEN VALLEY

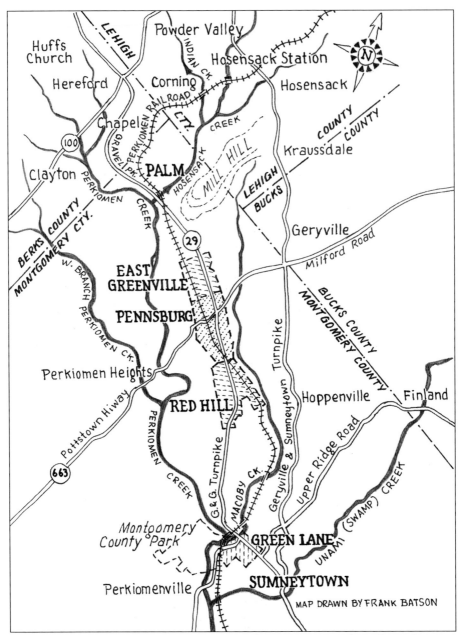

This map is a sketch of the Upper Perkiomen Valley as it appeared in the early portion of the 20th century. Prior to the construction of the dam at Green Lane, the Perkiomen Creek meandered through the region in a generally north-to-south direction. Several of the images illustrated in this book are from locations that are now under the waters of the reservoir, which was completed in 1956.

On the cover: In the early 1900s, ice-harvesting workers pause briefly while sending ice blocks up the inclined conveyor to the John Hancock Company icehouse in Palm. See pages 106 and 107 for more images and details of the ice-harvesting process. (Courtesy of the Schwenkfelder Library and Heritage Center.)

IMAGES of America

THE UPPER PERKIOMEN VALLEY

Jerry A. Chiccarine and David W. Luz
for the Schwenkfelder Library
and Heritage Center

ARCADIA
PUBLISHING

Copyright © 2007 by Jerry A. Chiccarine and David W. Luz
ISBN 978-0-7385-5485-3

Published by Arcadia Publishing
Charleston SC, Chicago IL, Portsmouth NH, San Francisco CA

Printed in the United States of America

Library of Congress Catalog Card Number: 2007926418

For all general information contact Arcadia Publishing at:
Telephone 843-853-2070
Fax 843-853-0044
E-mail sales@arcadiapublishing.com
For customer service and orders:
Toll-Free 1-888-313-2665

Visit us on the Internet at www.arcadiapublishing.com

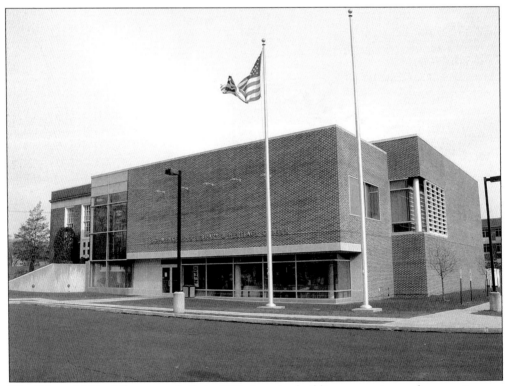

The Schwenkfelder Library was built in 1951. A major building expansion and renovation was completed in 2001 to allow for the additions of museum galleries, office areas, and a gift shop. The Schwenkfelder Library and Heritage Center, located on Seminary Street in Pennsburg, is a nonprofit organization dedicated to preserving and interpreting the history of the Schwenkfelders and the Perkiomen watershed.

CONTENTS

Acknowledgments		6
Introduction		7
1.	Perkiomenville	9
2.	Sumneytown	17
3.	Green Lane	25
4.	Red Hill	37
5.	Pennsburg	51
6.	East Greenville	73
7.	Palm	95
8.	Berks, Lehigh, and Bucks Counties	109

Acknowledgments

While it was the coauthors who first collaborated and conceived the idea of this book, it was only with the assistance of many others that this project was able to become a reality. There are two individuals who made essential contributions that allowed this book to be completed in this final form. First, we wish to thank postcard collector Charlie Moyer for granting us the use of his wonderful collection. Nearly half of the images in this book are from his longtime efforts to acquire and now to share these images. In addition, we wish to express our sincere gratitude to Upper Perkiomen Valley resident Narona Kemmerer Gebert. She performed much of the historical research and worked tirelessly to dig out interesting and informative facts. She contributed several important historic images and assisted in the final assembly of the book.

The authors made good use of the archives of the Schwenkfelder Library and Heritage Center. Approximately 30 percent of the images in this book are from the library's extensive collection. Most images are from the work of H. Winslow Fegley, who recorded hundreds of local photographs between 1900 and 1905. In addition, the authors wish to thank the entire staff and volunteers, some of whom had direct involvement. Specifically, they include archivist Hunt Schenkel; curator Candace K. Perry; associate director of research Dr. L. Allen Viehmeyer; and volunteer Charlie Shank.

The sketch of the map on page 2 was drawn by artist Frank Batson. We appreciate his good work and speedy completion of this drawing. Others who shared images or provided information and assistance include C. Edward Mosheim, president of the Hereford Township Heritage Society; Larry Roeder, editor and publisher of the *Town and Country* newspaper; Alan Keyser; Ed Bieler; and Vic Stahl.

In compiling the historic information, the authors used the archives of the *Town and Country* newspaper and the Historical Society of Montgomery County. We appreciate all the help from the many local residents who answered our questions and provided assistance.

To the residents of the Upper Perkiomen Valley—past and present, living and deceased—we dedicate this book. This is a part of your history.

INTRODUCTION

The natural resources preserved in the Upper Perkiomen Valley are a reflection of nature's abundance found throughout Pennsylvania. A tour of the area reveals scenic vistas combined with a rich heritage, making this community a desirable place to live. Numerous open spaces support abundant farming and other agricultural activities. Large tracts of wooded lands sustain a wide variety of wildlife in their natural environment. Geological formations left behind by the earth's physical formation and the unhurried movements of ice-age glaciers are found throughout the valley, notable along the Unami Creek and on Palm's Mill Hill. The earth's surface conditions ordered the course of water that flowed through the Upper Perkiomen Valley, generally from north to south. At the heart of the valley is the Perkiomen Creek, being fed by a number of smaller streams having beginnings in the higher elevations of surrounding hills. Evidence of a Native American presence in the valley can be seen in the great quantity of arrowheads, tools, and other materials recovered from farmers' fields and along the Perkiomen Creek.

After 1681, when William Penn was granted Pennsylvania, European settlers began arriving in greater numbers along the southeastern part of the state. These first settlers were Dutch, Swedish, and English. In the period from 1725 to 1740, the Upper Perkiomen Valley became the center of a large German population. Many of these settlers were subsistence farmers who left crowded, war-torn, and economically depressed homelands for opportunities for advancement in a new uncharted wilderness. Additionally, religious persecutions compelled others to heed Penn's call for toleration that did not exist in their German communities. The valley became home to a wide range of faith expressions, among them Lutherans, Reformed, Mennonites, Brethren, Schwenkfelders, and Roman Catholics. Their frugality, intelligence, and hard work ethic enabled them to survive these early years of settlement, filled with hardships and challenges. They cleared the land, worked the soil, performed milling operations by hand, and raised livestock.

The second half of the 18th century saw a rapid increase in settlement and productivity in the Upper Perkiomen Valley. Farmsteads, or "plantations" as they were called, were rapidly being established and expanded. Mills of many kinds increased along the banks of the Perkiomen and its tributaries, powerful sources both dependable and bountiful in flow throughout the year. These varied mills saw the production of flour, gun powder, lumber, linseed and other plant oils, and the mixing of animal feeds, as well as machine shops and forges, not only for use in the valley, but for the manufacturing of goods transported to the markets of the surrounding population centers. In addition to homes and rural trades, schoolhouses, churches, and meetinghouses for the conducting of religious services and education of youth began to be built.

In the 19th century, as more settlers arrived, pocket communities took form around river crossings or small general stores or milling operations. More people led to demands for better transportation and goods, and a number of private turnpikes and bridges were constructed in the valley. Eventually, by the 1870s, the railroad's extension into the valley brought rapid change and opportunities for the people of the growing communities. It was now possible to move goods and services to larger surrounding cities much more rapidly. As the 20th century approached, new and more specialized industries grew and dominated the town. In addition to agriculture, the Upper Perkiomen Valley became heavily involved in stone quarrying, cigar making, and large-scale harvesting of ice. The entire area was a beehive of activity, prosperity, and growth.

This Images of America book covers the early portion of the 20th century with an emphasis and focus on activities during the first decade. The goal of the book is to give the reader a glimpse of the life and history of the area at that time. The book is divided into eight chapters, which represent the various villages and boroughs established at that time. Specifically, these include seven Montgomery County places: Perkiomenville, Sumneytown, Green Lane, Red Hill, Pennsburg, East Greenville, and Palm. The final chapter covers a grouping of several small villages and places in the northern edges of the valley. They lie in three separate counties: Berks, Lehigh, and Bucks. The people who lived in these places proved proficient in utilizing and developing the natural resources of the region.

While the individual towns in which the people of the Upper Perkiomen Valley lived are united by a similar history, each tells its own unique part of this story. Readers will find within these pages an impression of who these people were: their faith, their architecture, and their commerce, as well as an appreciation for the beauty and natural resources of the Upper Perkiomen Valley.

One

PERKIOMENVILLE

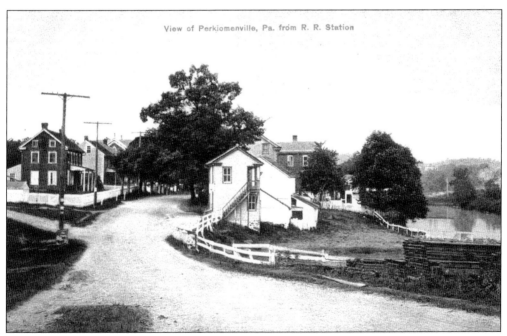

The village of Perkiomenville straddles both Marlborough and Upper Frederick Townships. In the early years of the 20th century, Perkiomenville was in the middle of a highly traveled route from the northern regions of the Upper Perkiomen Valley to the more populated and industrial areas farther south. Passage through the area was accomplished by either rail or over dirt roads by horse-drawn wagons. In this view captured before 1912 is a view of Perkiomenville as seen from the railroad station. It was about this time that the automobile began to show in increasing numbers on these same dirt roads.

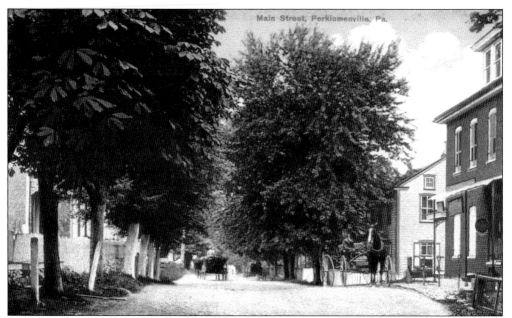

In the early 20th century, there were about one to two dozen houses in Perkiomenville. There were, however, a number of businesses ready to serve the local folks as well as travelers and those in neighboring communities. Perkiomenville had a post office, a general store and tavern, an Odd Fellows lodge hall, a community hall, a creamery, a blacksmith shop, and a butcher. In this postcard sent in 1912 are several travelers and shoppers along Main Street.

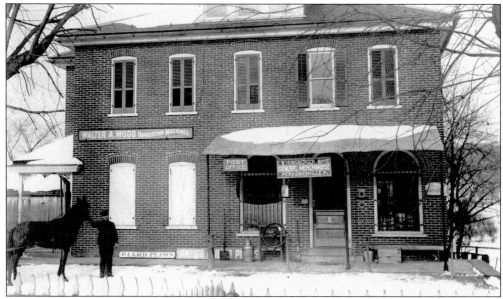

The Perkiomenville Post Office was generally located in either Rahn's Hotel or Hunsberger's General Store, depending on who was appointed postmaster. In this 1907 winter scene, one sees that the post office was housed in the general store operated by C. W. Hunsberger. This store also handled all kinds of agriculture implements, hardware, paints, groceries, clothing, dry goods, and a variety of inexpensive, small useful articles. This building still stands along Gravel Pike as a private property.

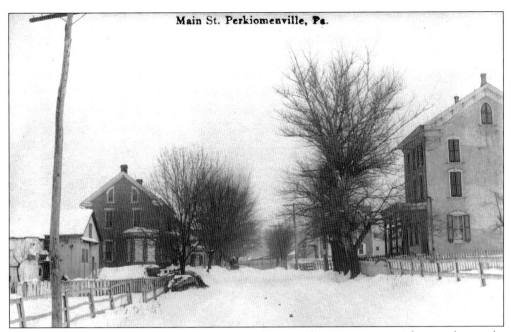

During the warm weather months, muddy roads were always a nuisance if not a downright impediment to successful travel. Wintertime travel was even more challenging. There were no plows to clear the streets. Clearing, if done at all, was accomplished by hand shoveling. In this c. 1907 view is a snowy Perkiomenville Main Street. At times like these, hardy souls such as rural mail carriers would have to resort to sleighs or horseback to ensure delivery.

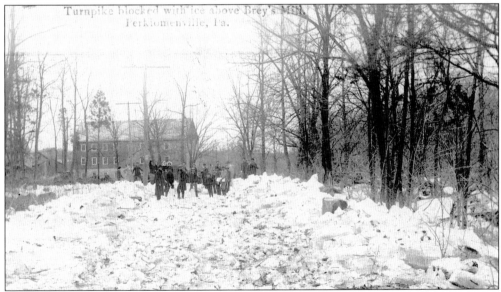

In this c. 1906 view of the Perkiomen and Sumneytown Turnpike (Gravel Pike), unusual weather conditions have caused an ice blockage above Brey's Mill. Located below Snyder Road, the old mill site had quite a history. The original mill dates back to 1784. The original grist- and sawmill later converted to oil, powder, fulling (shrink and thicken), carding (cleaning), and planing operations, to name a few. The Kleinbach family was one of the last well-known owners of the mill, which was razed in the 1950s.

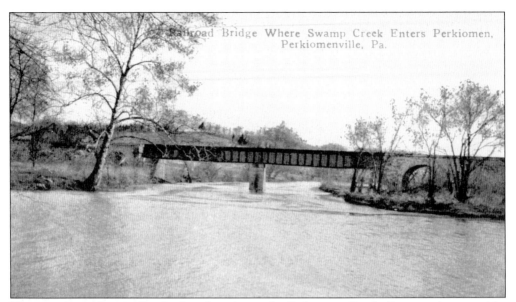

There were two Swamp Creeks that flowed into the Perkiomen Creek. One, on the west side, joined the Perkiomen just north of Schwenksville. The other joined the Perkiomen from the east at a point just south of Perkiomenville. In 1917, the United States Geographic Board decided to end the confusion by renaming the east side of Swamp Creek to Unami Creek in honor of a branch of the Lenni-Lenape that once inhabited this area. This 1917 postcard view shows the railroad bridge where the old Swamp Creek joined the Perkiomen Creek near Perkiomenville.

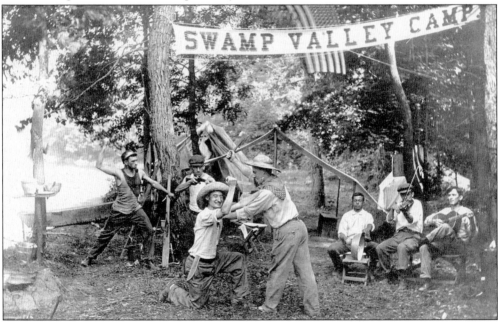

Although there are various creeks and roads bearing the swamp moniker, there are few if any swamps of any serious nature in the Perkiomen Valley. Around 1912, this image was recorded in Perkiomenville of a group that pitched its tents and set up camp under the American flag and the banner of the "Swamp Valley Camp." The camp was typical of many that were favored by visiting groups seeking a change of pace.

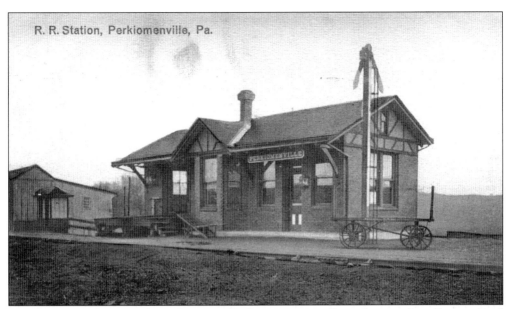

The first station house at the Perkiomenville depot was a small wooden structure that was used for years after the railroad arrived in the village about 1872. When the time came to replace this original structure, it was determined that a larger, more substantial brick building was merited by the high revenues generated at this station. The popular livestock sale relocated from Rahn's Hotel to a site south of this station in 1929. The rail station is long gone, but the sale event lives on in Perkiomenville.

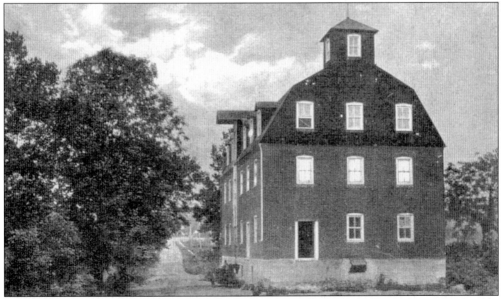

Recorded here on a postcard dated 1916, the Perkiomen Roller Mills building was constructed in the mid-1800s. Sometime in the early 20th century, the Nice family acquired and operated the mill for years before retiring the building to idleness. In the 1960s, Sasha Siemel, a well-known jungle hunter and explorer, used the building for his museum. After that, it was converted into a private residence. In 1993, a deadly fire damaged the building and again rendered it vacant. As such, it still remains today.

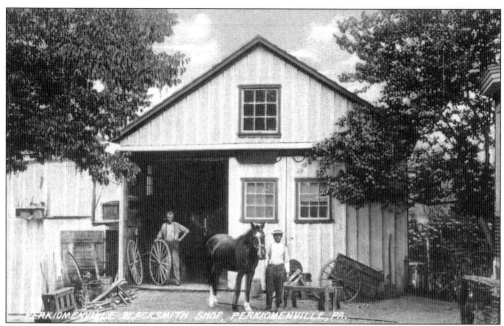

The old-time village blacksmith made and repaired all kinds of household utensils, hardware, tools, and farm equipment. Some blacksmiths operated in the area until about 1930. In the later years, they mounted the forges and anvils on the backs of pick-up trucks and traveled from farm to farm to do general repair work. In this *c.* 1910 view is the Perkiomenville blacksmith shop of John L. Kiler and local resident Charlie Hunsberger with his horse, waiting to be shod.

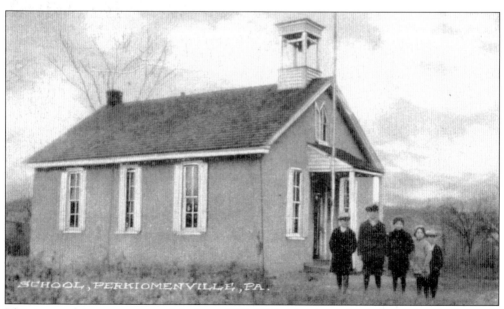

This postcard image was recorded about 1910. This school was located on the Marlborough Township side of Perkiomenville. The school was one of five one-room schoolhouses located within the township limits. Today the building is a private residence on Crusher Road.

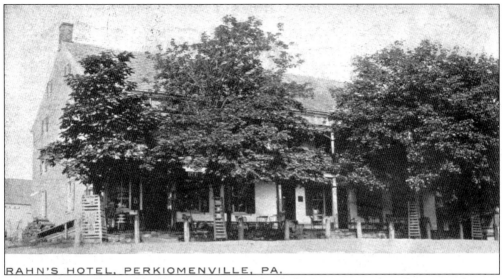

RAHN'S HOTEL, PERKIOMENVILLE, PA.

The Perkiomenville Hotel had been in the Rahn family for many years when this postcard image was captured around 1907. Over the years, the hotel housed a store and sometimes the post office. Rahn's hotel benefited from visiting guests who came to the area for camping, hunting, and fishing. It was also a popular meeting and eating place because of the livestock auction held in an adjacent building. Although bypassed by the new route of Gravel Pike, this beautiful building operates today as a restaurant and bed-and-breakfast.

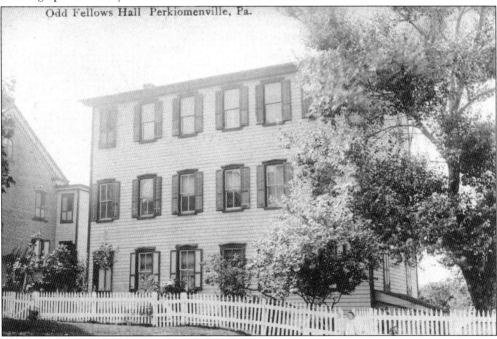

In 1884, the Independent Order of Odd Fellows built this structure near Rahn's hotel in Perkiomenville. At the time, this charitable and beneficial organization had about 100 members who met on a weekly basis on the third-floor lodge hall. The lodge shown above around 1906 was active into the 1920s. After that time, its members joined with the Pennsburg chapter. Today the Perkiomenville Odd Fellows building is a residential property.

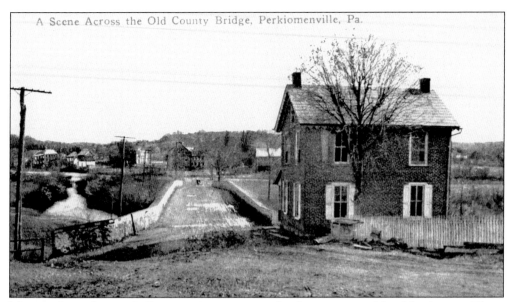

Many early roads were built over private property by the owners and local businesses. These roads were maintained through toll charges passed on to the users. Many of the bridges over waterways were built and maintained by the county. Here is the old stone county bridge built over the Perkiomen Creek as it appeared about 1910. At right is the Perkiomenville brick tollhouse that stood next to the bridge. The bridge is still standing, although it is closed to traffic. The tollhouse was demolished many decades ago.

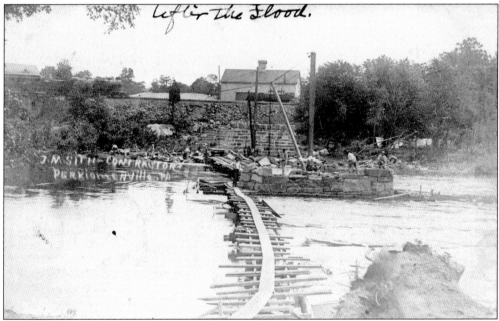

James M. Smith of Perkiomenville was a contractor who did construction for the Montgomery County commissioners. He was frequently the successful bidder on contracts for the building of bridges in the Upper Perkiomen Valley. In 1905, a typical winning bid to build a bridge was about $5.50 per cubic yard of masonry installed. In this 1907 image is the Smith Company making repairs to a dam site near Perkiomenville after a disastrous flood.

Two

SUMNEYTOWN

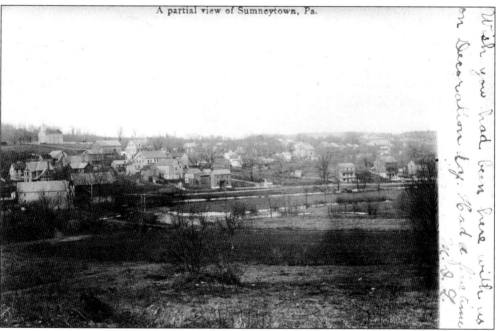

In this postcard view of Sumneytown, one can see how the village appeared around 1906. Frieden's Union Church, one of the more prominent buildings overlooking the village, can be seen at the top of the hill on the left side of this image. Sumneytown was named after Isaac Sumney, who was one of the earliest innkeepers. He was of French Huguenot descent and immigrated into the Perkiomen Valley around the mid-1700s. By 1762, he was given his first license to operate a tavern in Marlborough Township. Sumneytown was a location of powder mills as well as sawmills, gristmills, and flour mills. In the early 1900s, there were cigar factories, private schools, and hotels to accommodate tourists. Until 1928, Sumneytown had been home to a German-language newspaper that enjoyed a large circulation. *Der Bauern Freund* (the farmer's friend) was first published here in 1828.

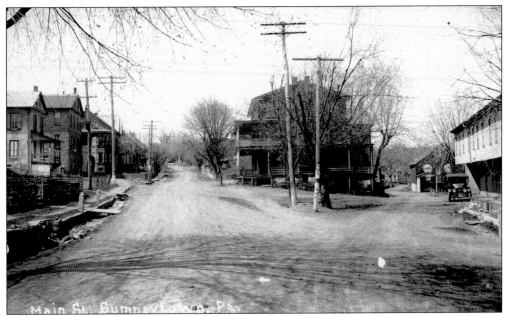

The center of Sumneytown was at the junction of three great roads. In the early period of development, it was a busy metropolis due to the heavy traffic of stagecoaches and delivery wagons. In this view captured around 1906, the center of the village is crossed by these three roads, which at this time were all toll roads. At center is the Sumneytown Hotel. A general store and post office, as well as other shops and hotels, were in close proximity.

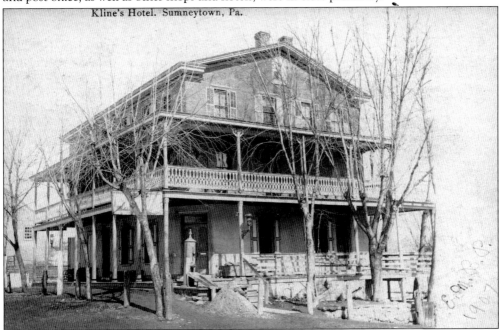

On February 9, 1907, the Red Lion Hotel was sold to Joseph Kline of Trumbauersville for $13,000. Kline's Hotel had many owners and many names over the years. The hotel, built in 1762 by Isaac Sumney, was rebuilt by Samuel R. Barndt after a fire about 1880. Most commonly known as the Sumneytown Hotel, the building still stands at the center of the village.

In this view looking south on Main Street around 1912, one can see two distinct but equally appealing styles of architecture. Many of the homes were built on a substantial scale due to the local wealth generated by the active mercantile and manufacturing economy. While prosperous and economically important to the area, the number of permanent Sumneytown residents remained relatively small. By the middle of the 20th century, the village had a population of only about 800 people.

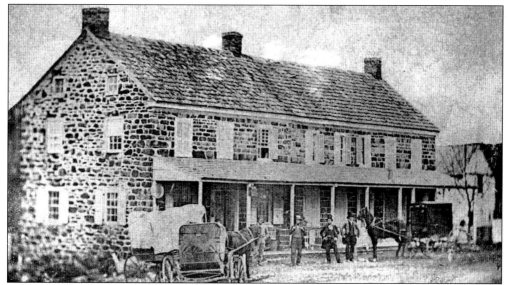

In this rare early photograph image are the Sumneytown Store and post office. The original structure dates from 1790, when it was built by industrialist Lorenz Jacoby. The building was greatly expanded shortly after the image above was captured around 1856. At the time, it was a major community center and marketplace. A general store no longer operates out of this location, but it is still a post office on Sumneytown Pike.

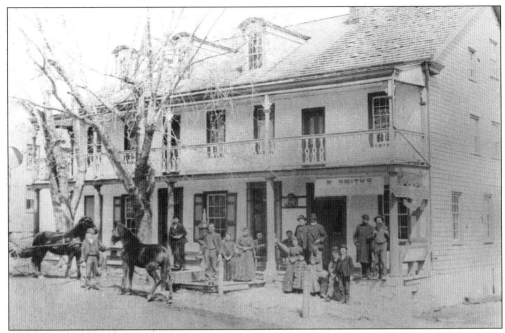

Commonly known as the Kaufman House, this structure was built in 1850. Around 1888, many members of the Smith family posed for this image in front of the inn, which bore their name at the time. The Smith family moved from Windsor Township in Berks County after it acquired ownership of this important and active business. In later years, the building would see service as a cigar factory, a roost for a chicken farm, and a bed-and-breakfast. More recently, it had been a tavern and restaurant.

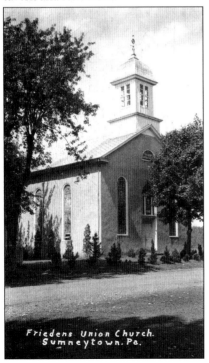

Friedens Union Church was built in 1858. For a century, the Lutherans and the Reformed congregations each shared the same building. Over the years, the joint councils performed additions, repairs, and renovations to keep the facility up to date. In 1958, the Lutheran congregation erected a separate church building and the Reformed congregation stayed at the original church shown here in this 1940 postcard view. St. John's Lutheran Church is situated along Main Street in Sumneytown.

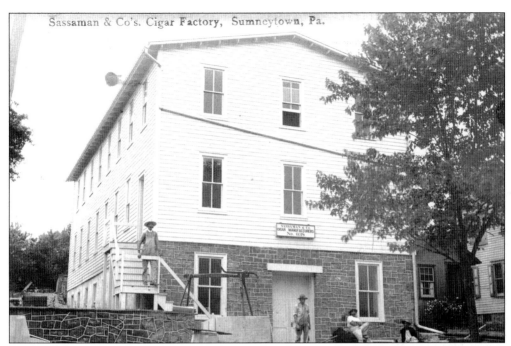

In the early 1900s, there were several thousand workers employed in cigar manufacturing in eastern Pennsylvania. At its peak, Sumneytown had three factories. In the above image from the fall of 1905, workmen are putting the final touches on the newly completed building for the Sassaman and Company Cigar Factory. Shown below is another Sumneytown cigar factory. This large three-story building was constructed on Main Street in 1896 by Samuel Barndt. It operated for years as the Boltz Clymer and Company cigar factory until the late 1920s. City-based automated machine processes and the popularity of the cigarette forced the handmade cigar into obsolescence. Many vacant cigar factories transitioned into clothing manufacturing, and in recent years many have become residential complexes.

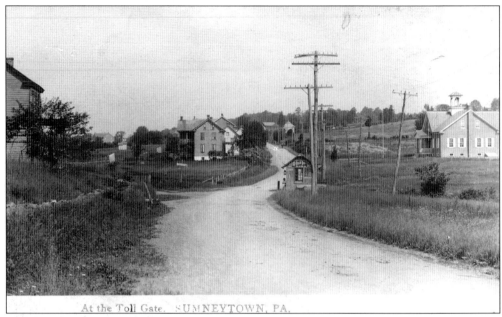

The Sumneytown and Springhouse Turnpike was completed in 1848. In this view from around 1915 is the tollgate house set up along the south end of the village. This toll road was a major artery for Philadelphia travelers heading northwest. At the right side of this view is the brick township schoolhouse built at Sumneytown in 1910.

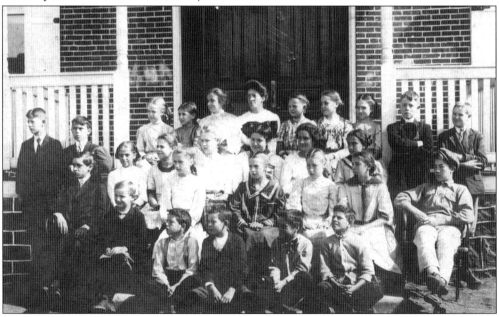

By 1842, the Sumneytown Academy was schooling students in literature and other branches of education. This progressive educational program helped local youth attain a high scholastic aptitude. In 1882, the county public or "common school" was created. For a period, the academy and the independent school district ran concurrently. In the above view is a group of students in front of the public township schoolhouse built in 1910. The building is currently an antique store.

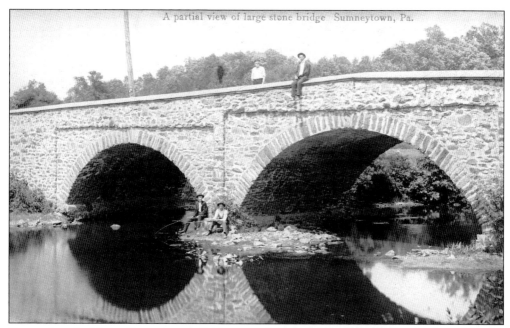

Proposals to build the Sumneytown Bridge over Swamp (Unami) Creek date back to the years before the American Revolution when the area was part of Philadelphia County. In 1787, Montgomery County authorized the project. Travelers used the bridge continuously until 1928 when the county built a bridge a short distance upstream. The old bridge still exists along a closed portion of the original road.

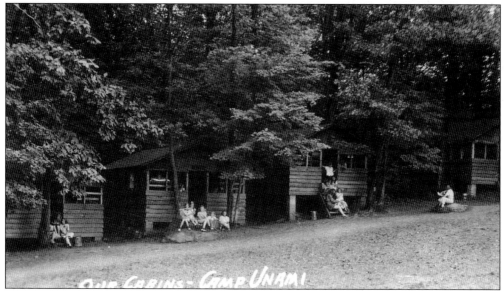

Camp Unami is a typical summer camp that has operated in Marlborough Township many years. The 129-acre site is located along the Unami Creek. Camp Unami was sponsored by the Baptist Church when this image was captured in the 1940s. The camp provided boys and girls from 8 to 13 years of age a chance to enjoy several weeks of camping and sports. In recent years, the camp has provided low-income city children an opportunity to also learn fire safety, nutrition, and sound health education.

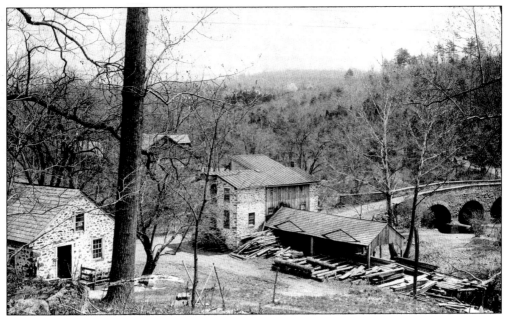

This Sumneytown sawmill is shown in the early 1900s, when it was last operated along the Unami Creek by Alvin Wetzel. In 1848, it was a linseed oil mill operated by a man named Heebner. Later it was converted to a gristmill, and it was Alvin Wetzel's father, John, who used it as a sawmill. Located near Swamp Creek and Magazine Roads, the site is now owned by the township and is earmarked for restoration.

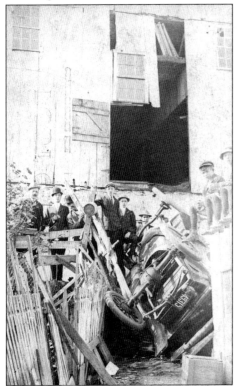

By 1912, most folks had successfully made the transition from the horse-drawn carriage to the horseless carriage. That was not so here! According to family and friends, Frances Zeiler of Sumneytown drove through the front door of the barn as she yelled "Whoa!" In her attempt to remove the automobile from the barn, she never opened the barn door, nor did her feet ever touch the brakes. Her family recorded the wreck in this image as it rested along the side of the barn bank.

Three
GREEN LANE

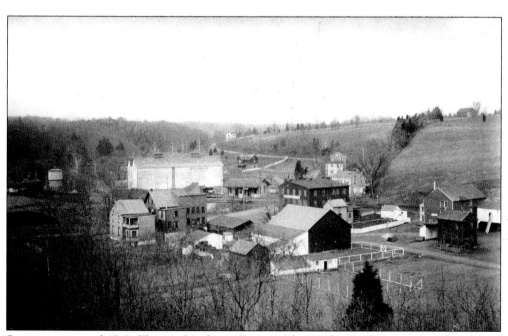

Some time around 1743, Thomas Mayburry II, a wealthy Quaker, built an iron bar forge along the Perkiomen Creek. The enterprise became well known as the Green Lane Forge as a result of the evergreens that visitors would encounter along the main highway leading to the forge. As the village grew, it also became known as Green Lane. In this early-20th-century view, the John Hancock Ice House (the large white building) is on the spot where the original forge once stood near the Perkiomen Creek.

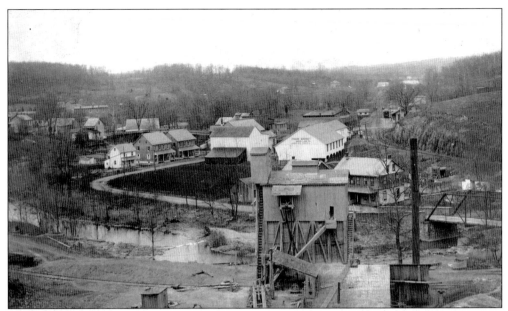

This partial view of Green Lane was recorded around 1908 in a southwesterly direction at what might be described as a commercial and industrial enterprise zone. As a point of reference, note the railroad station in the upper right-hand corner of this image as it peeks out from the side of the cutout hill. The large white building at the right center is the Frank Barndt lumber, coal, and feed business. In the foreground, the Macoby Creek flows in front of the stone crusher of a quarrying operation.

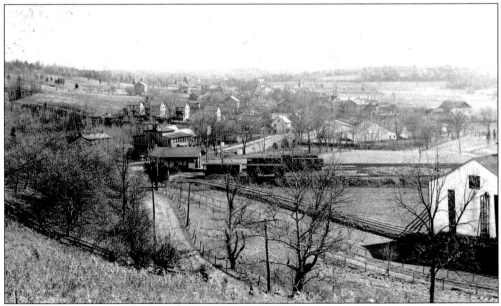

The railroad had been completed to the village of Green Lane in 1872. By the time this image was captured in the early 1900s, the Green Lane station had become the busiest station of the entire Perkiomen rail system. While other stations on the line had a good mix of passengers and freight, the Green Lane station handled fewer passengers but did a brisk business in several kinds of freight, including stone and ice.

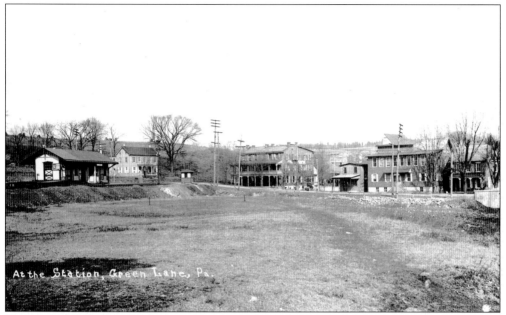

This c. 1907 view of the station was taken looking north at a group of notable buildings in Green Lane. The large building at center is the Keystone House (later the railroad house). Built in 1860 and razed in 1960, it was a busy place in its heyday. Another business of note is the large building second from the right. In the late 1800s, this was the first cigar factory in Green Lane. It continued under different owners for several decades. Later the upper floors were destroyed by fire. The restored building is currently an apartment house.

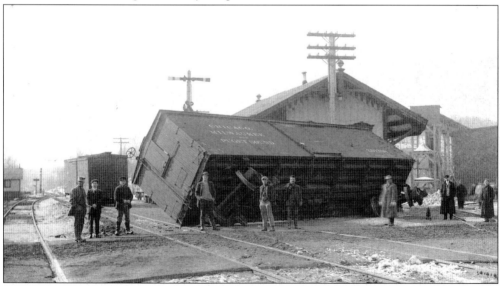

Green Lane was the heaviest shipper of freight on the Perkiomen branch of the Reading Railroad system. Crushed stone was shipped from three different major quarries, and ice was shipped from four different icehouse operations. In addition, there was the usual amount of lumber and farm products leaving the station. It is no wonder that with such a high level of activity, accidents would happen. In this early-1900s view, this particular accident nearly wiped out the station house.

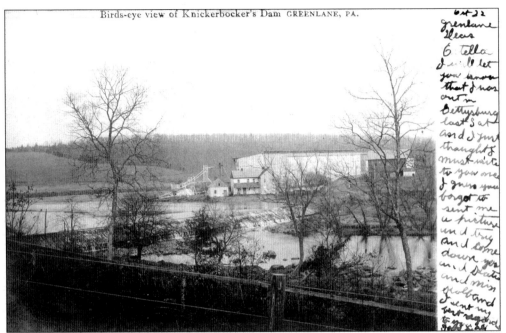

All of the ice plants of the Upper Perkiomen Valley were noted for their quality. The banks of the Perkiomen Creek were free from mining and factory pollution. Therefore, the water was found to be pure, clean, and healthful. The two most important destinations for the ice were Philadelphia and Washington, D.C. In this bird's-eye view are the Knickerbocker Ice Company dam and icehouse. Soon after this image was recorded in 1905, this plant was acquired by the American Ice Company.

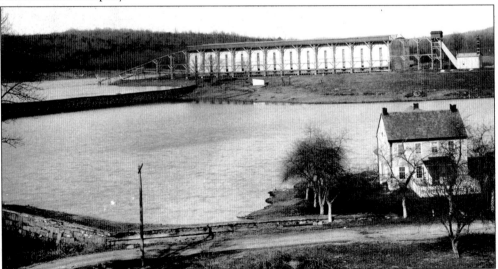

The above image was recorded on a postcard postmarked in 1910. It shows the Deep Creek icehouse, which was the second Green Lane ice-harvesting operation owned by the American Ice Company. During the winter ice-harvesting months, as many as 17,000 cakes of ice were housed in a single day. There was generally not enough local out-of-season farm help available to perform all the work. In many cases, extra day help was brought in from Philadelphia. Ice cutters were paid about $1.50 for a hard day of labor.

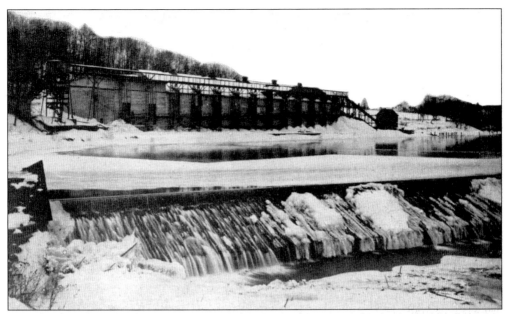

The Hancock Company owned two ice plant operations in Green Lane, one was the largest in the immediate area. It encompassed two dams that covered a total of 45 acres and one gigantic icehouse. The icehouse was over 310 feet long, 90 feet wide, and three stories high. It had the capacity to hold 25,000 tons of ice. This plant was conveniently located on the Perkiomen Creek on the west side of the train station. In this undated view, ice cutters are seen at work in the distance at a Hancock Green Lane icehouse.

By the end of March 1907, 17,000 tons of ice was being warehoused in the Hancock icehouse near the train station. On March 30, disaster struck in the form of a spark from a locomotive. Shortly after a locomotive pulled cars from the icehouse siding, a local boy saw the flames on the roof. Because of the straw and sawdust used to insulate the ice, the fire spread rapidly and a hastily formed bucket brigade could do little. The total loss was $35,000. Insurance helped rebuild a new house in time for the next season's work.

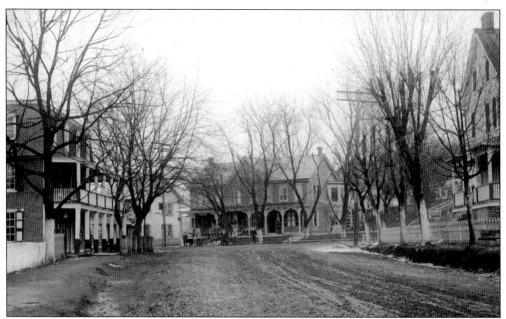

This early-1900s view shows the junction of three great turnpikes that met in Green Lane. The photographer is looking north on the Perkiomen and Sumneytown Turnpike (Route 29) completed to Green Lane in 1849. A traveler making a right turn at the junction would be heading east on the Sumneytown and Springhouse Turnpike (Route 63), which extended to Green Lane in 1848. A traveler making a left turn at the junction would be traveling on the Green Lane and Goshenhoppen Turnpike (Route 29), completed in 1851.

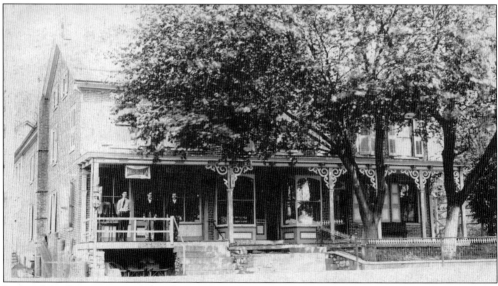

Located at the junction of the three pikes, the Green Lane general store dates back to 1848, when it was known as Poley's Store. By 1874, the business had been acquired by Jacob Allenbach, who ran it until he sold out to Frank F. Sowers in 1914. In this view from 1914, it is a good bet that one of the gentlemen pictured is none other than Sowers himself. During some of the following years, the Green Lane Post Office was housed in the store. In 1948, this business was purchased by the Yoder family, which ran it for many years.

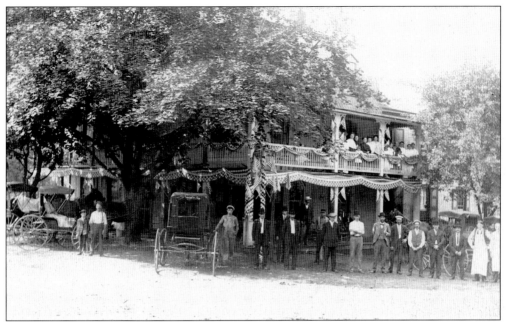

There were two hotels in Green Lane in the early 20th century. In this view, the Green Lane Hotel is all decked out for a patriotic celebration around 1907. The hotel was built in the mid-19th century at the junction and around the time of the completion dates of the three turnpikes. The hotel was in a prime location and did an active business in the days of the railroad. The building was razed in 1965.

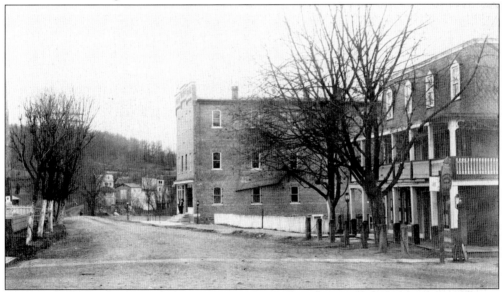

Red Men's Hall was erected in 1907 for the Tohickon Tribe, Improved Order of Red Men. This fraternal organization had been formed in 1896 for the purpose of providing social fellowship for men of the area. The hall served other functions. The first floor was used for commercial purposes, which included banking and retail stores. The second floor served the organization's needs as well as other community affairs, such as plays and graduations. In 1973, the hall was sold to the Goschenhoppen Historians.

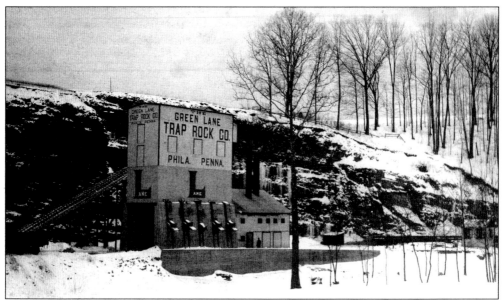

From the early days, quarrying operations of all sizes have been able to capitalize on the different types of geological resources around Green Lane. In some instances, individuals would buy a plot of land and simply start hand cutting Belgian paving blocks out of the "granite" formations. From 1900 to the mid-1930s, Green Lane was the biggest shipping point of hand-cut stones used to pave Philadelphia streets. Another geological type of rock known as "trap rock" generally required a large organization and specialized equipment to produce large quantities of finished and crushed stone. Within Montgomery County, quality trap rock is only found in a few small areas. *Trap* is derived from a Germanic word meaning "steps" or "stair." In the process of quarrying this stone, the term trap rock refers to the vertical and horizontal fracture planes that tend to leave an image of piles of blocks or stairs. In the view above is a portion of the operation of the Green Lane Trap Rock Company as it appeared in 1911. Below is the Hancock Stone Quarry that operated in Green Lane about the same time.

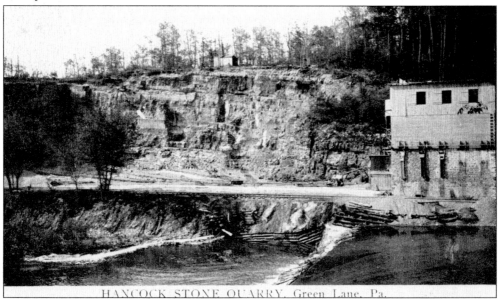

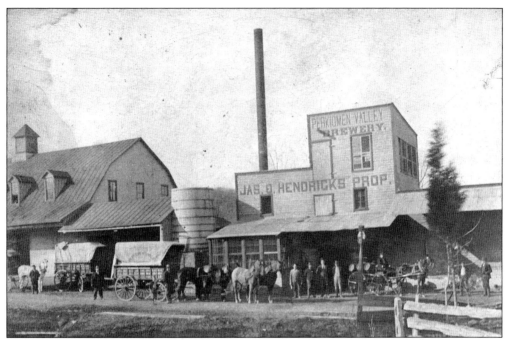

Shown here around 1900 is the Perkiomen Valley Brewery. James O. Hendricks started the brewery around 1895. In 1905, the business was sold to Samuel Z. Jerzy. An advertisement in a 1906 *Town and Country* newspaper indicated the following brews: ale, beer, porter, lemon soda, sarsaparilla, raspberry, birch, orange, root beer, ginger ale, celery soda, cream soda, and pear cider. The brewery had several owners after Jerzy, and the main building was later demolished around 1920.

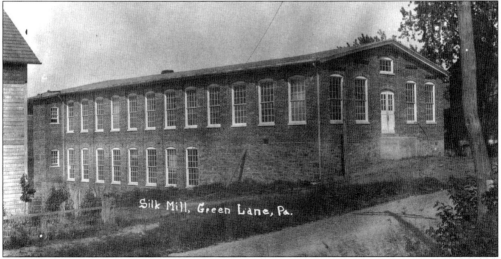

The Amalgamated Silk Company was located at the east end of Green Lane, just outside the borough limits. This large mill provided employment to many Green Lane citizens, both men and women. The local folks could earn good money and still go home for lunch. The silk mill closed in the 1930s. After a brief vacancy, the Style Parlor Frame Company, a furniture manufacturer, occupied the building. It continued operations until a fire completely destroyed the building in December 1964.

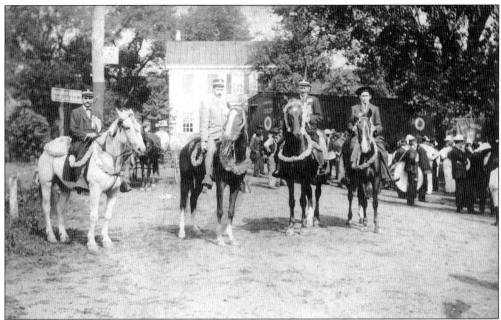

Green Lane was one of the smallest municipalities in Montgomery County. The borough did not let its small size keep it from participating in the same kinds of community events enjoyed by the larger villages nearby. In the early years of the 1900s, the shed behind the Keystone House Hotel was the site of all kinds of fairs and shows. The area around the hotel was also the starting point for mustering frequent parades. Above are several of the prominent town leaders mounted up and ready to lead the celebration around 1907. Below is a visiting band marching along Main Street in front of a long line of parade participants around 1909. While the band remains unidentified, it was not the Green Lane Fife and Drum Corps, which was not organized until 1912.

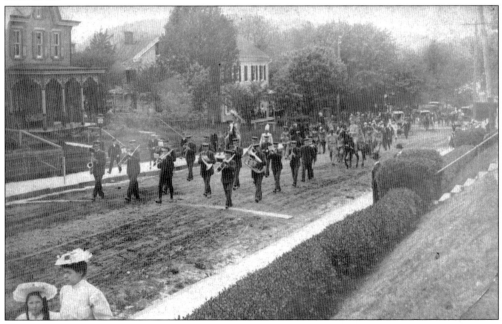

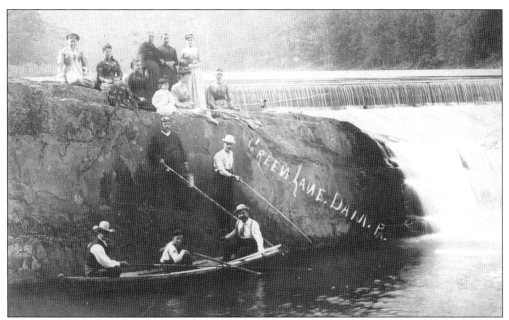

At one time there were many dams along the waterways of the region around Green Lane. Early in the 19th century, there were 15 mills operating between Green Lane and Perkiomenville. A century later, the number of dams had dwindled to seven and the utility of most dams now centered on ice harvesting. In this 1906 view above is a fishing party cashing in on one of the many fringe benefits of a Green Lane dam.

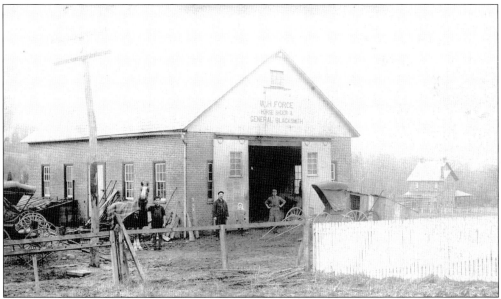

As early as 1884, W. H. Force had been in a blacksmith partnership under the name of Miller and Force. Its shop was conveniently located at the rear of the Yost Carriage Shop in the 100 block of Main Street. Force became sole owner by 1891, and when the original shop was destroyed by fire in 1902, he built this brick shop across Maple Alley. When the blacksmith business declined, Charles Gronert bought the property in 1928. The Gronert family soon converted it to a welding and fabrication business.

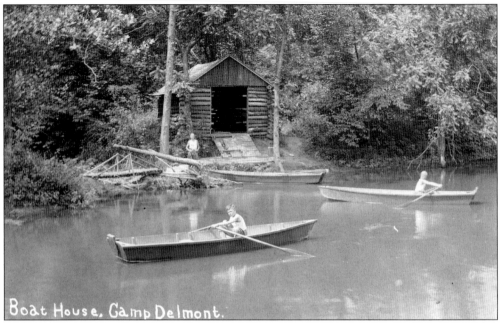

Camp Delmont has been a major focus for area Boy Scouts since it was started in 1916. In this c. 1921 postcard view of a boathouse, several Boy Scouts are practicing their rowing skills on the Unami Creek. Camp Delmont is located in Marlborough Township on the east side of the borough of Green Lane. The camp was thought to be in Green Lane since thousands of the early cards like this one were sent home and carried the Green Lane postmark.

Upper Perkiomen Valley Park was opened by Montgomery County in Marlborough and Upper Frederick Townships on February 23, 1939. In this late-1940s postcard, it is apparent that the park became quite a success. Over the years, the county has made additional acquisitions, and Green Lane Park is a joining of Upper Perkiomen Valley Park and the Green Lane Reservoir, which now totals over 3,000 acres combined. With three bodies of water totaling 870 acres, the area is host to many kinds of outdoor activities.

Four

RED HILL

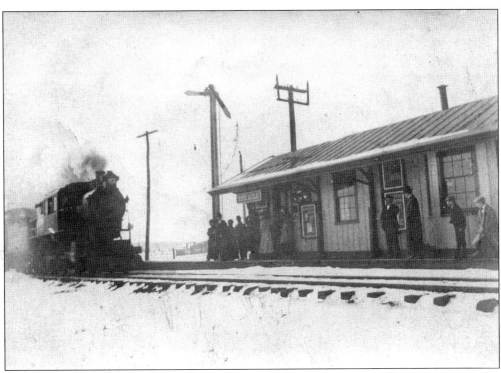

The Perkiomen Railroad reached Red Hill in 1874. The railroad opened up new markets for agricultural products as well as manufactured goods. The train allowed local residents greater access to the larger urban areas of Philadelphia and Allentown. The culture and city influences were felt in the once rural community. In this c. 1905 winter scene is a northbound steam locomotive about to take on passengers at the Red Hill station.

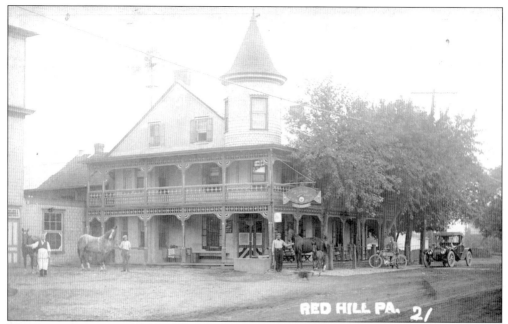

The original section of the Red Hill Hotel dates back to before 1800. In 1811, the Hillegass family opened it as a public house and named it the Hillegassville Hotel. The hotel was the hub of activity before and after the village became the borough of Red Hill. In this view taken about 1912, it was known as the Bergy Hotel. Recent owners included the Rutkowski family, which operated the hotel for almost four decades before it was razed to make way for the Turkey Hill Mini Market, which opened in December 2004.

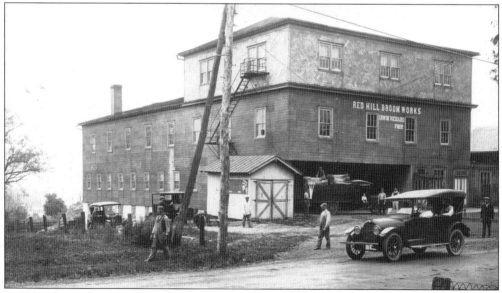

In 1906, this multipurpose building was completed as an attachment to the Red Hill Hotel. The first floor was used to continue the famous blue-ribbon horse sales that were held in the stable on the old site. The second level was prominent as the home of the Red Hill Broom Works. The upper floor was used as a local social hall by organizations such as the Knights of Friendship and the Patriotic Order of the Sons of America. This building was razed in July 1983.

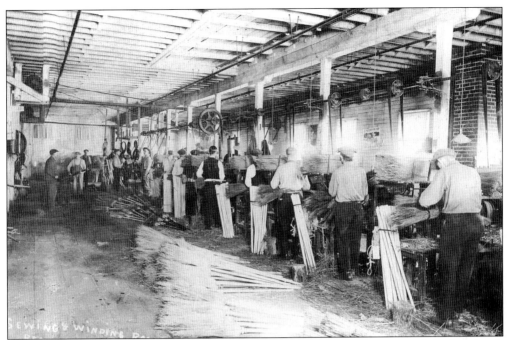

In this interior view of the Red Hill Broom Works, workmen perform some of the handwork necessary to produce these brooms noted for their quality. Irwin Richard founded the company in 1906. He operated the firm until his death in 1960. His three sons continued to operate the company until 1974, when it was sold to the Hamburg Broom Works.

One of the Upper Perkiomen Valley's earliest houses to be constructed of brick was built at Sixth and Main Streets. This c. 1914 view shows the house that Josiah "Jesse" Hillegass built across the street from his Red Hill Hotel in 1847. Note that the electric pole at the center of this image is newer, since electricity was first provided to the borough around 1910. The pole is long gone, but the house still stands and is an attorney's office.

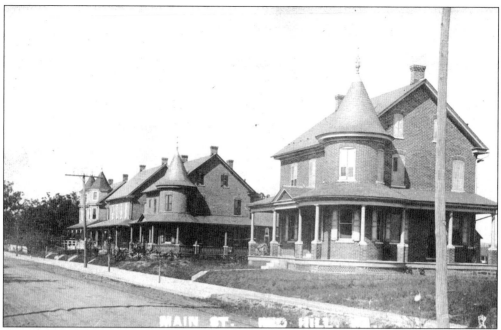

Red Hill has a rich heritage associated with the various styles of architecture found along its streets. The largest number of Victorian buildings in the Upper Perkiomen Valley can be found within the borough. This view of Main Street looks north from Fifth Street at several fine Victorian examples that convey the flavor and character of the area in the early 20th century.

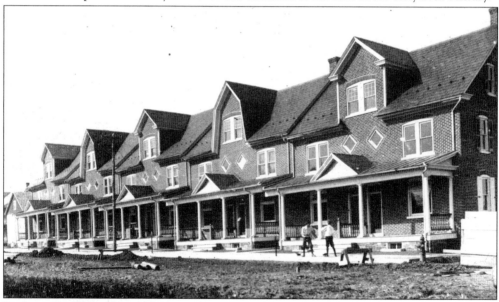

In the early 1900s, the nearby cigar factories could not get enough employees to satisfy their needs. Some of the workers traveled miles, and many wished to buy homes closer to work, but there was a housing shortage. Cigar factory owners such as Lucian B. Miller, John P. Kline, and a Mr. Trump decided to spearhead an effort to construct affordable single, double, and row houses in the borough of Red Hill. In this postcard view dated 1912 are the new row houses built on Adams Street.

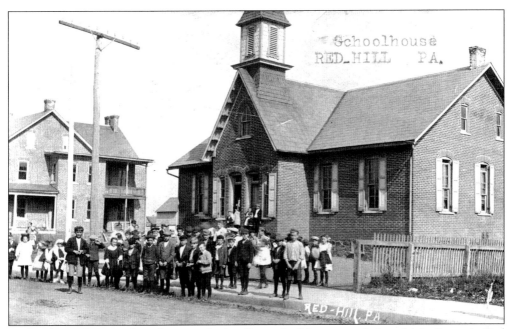

In the above photograph is the second schoolhouse building erected along Main Street in Red Hill. It was built in 1901 as part of the Upper Hanover Township school system. In 1902, the jurisdiction changed with the incorporation of the borough of Red Hill and the formation of the Red Hill Borough School District.

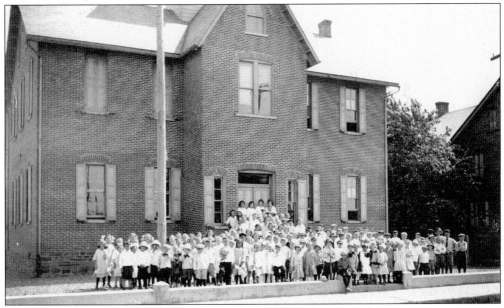

In this image recorded about 1913 is the third Red Hill schoolhouse building. The proposal to create this structure was met with some opposition among the citizens when it was announced to build a second story on the existing schoolhouse. A petition in opposition of the plan was circulated but dismissed due to an insufficient number of signers. This expanded third school building was used until it was vacated by the Red Hill School District in 1932. The modified building is currently used by the Bible Fellowship Church.

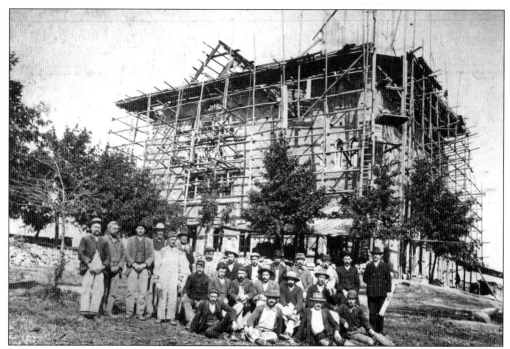

St. Paul's Lutheran Church built its first wooden structure near Red Hill in 1750. The current church is actually the fourth building erected on that site. In this 1896 image, the current building is under active construction. It was dedicated the following year.

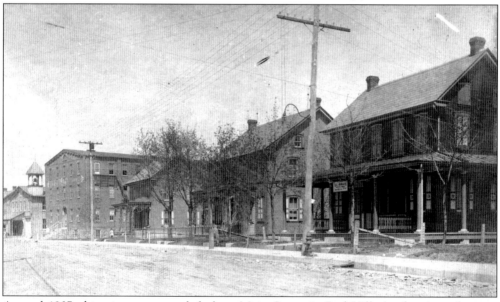

Around 1907, this view was recorded along Main Street in Red Hill. At the time, the post office was housed in the building on the right. While during this period the post office had several different locations, this one was somewhat unusual in that it was not a general store. The building was the shop of harness maker Robert E. Jackson. Jackson became postmaster in 1905, when the name changed from Redhill to Red Hill. This building is used today as a private residence.

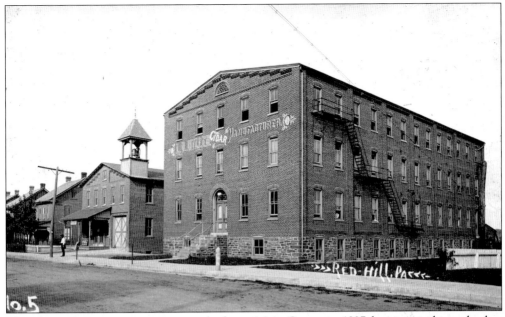

The above three-story structure was built on Main Street in 1897 by cigar industry leaders Lucian B. Miller and John P. Kline. At its peak in the early 20th century, there were 300 employees at this Red Hill location. The factory continued to make cigars until automation caused a decline of the handmade cigar industry in the late 1920s. Later the building was utilized as a clothing factory, and presently it contains residential apartments and the Upper Perkiomen Valley Library.

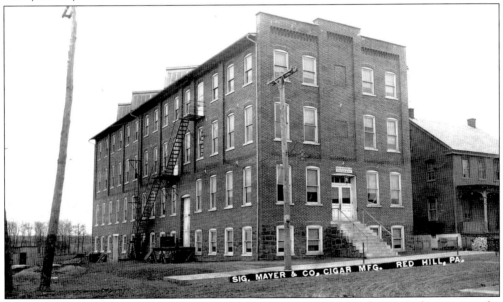

The S. C. Moyer cigar factory building was erected in Red Hill around 1890. Its location on the south side of Sixth Street near the railroad made for the convenient receipt of materials and shipment of finished products. Following it closing as a cigar factory, the building was used by the Red Hill Rug Company, which manufactured and sold rugs nationally until the 1950s. Recently the building has been used as a residence.

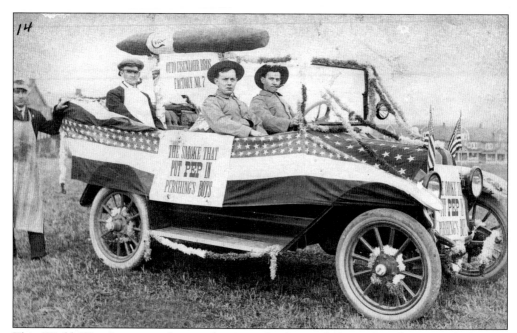

This World War I vintage photograph postcard advertised Cinco brand cigars, which were manufactured by the Otto Eisenlohr factories. It was postmarked out of Red Hill, which did not have a cigar factory run by the Eisenlohr Company. One can only conjecture that this well-decorated early automobile was a participant in a Red Hill parade celebration. Cigar factories used such tactics to help sell their products and to try to lure new workers into their employment.

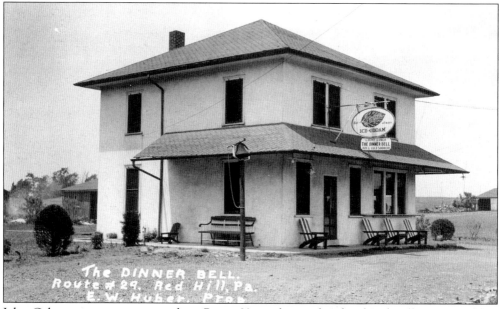

John Gehman ran a restaurant along Route 29 on the south side of Red Hill. He served hot dogs, hamburgers, ice cream, and sodas. In 1938, he sold the business to the Huber family, which adopted the Dinner Bell name and extended the menu to include a variety of hot and cold sandwiches. The restaurant advertised a "light lunch." The proprietor was Esther Walters Huber, who continued the business until 1954. Today the site is a private residence.

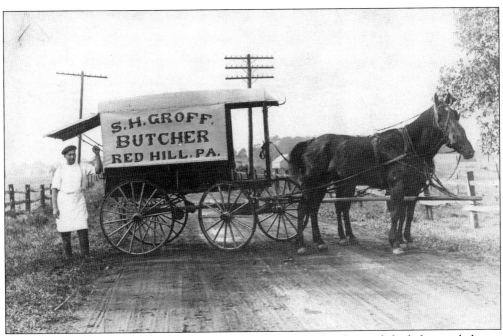

It is apparent from these two images that a century ago the butcher and the baker made house calls. Butcher Samuel H. Groff (seen in the above postcard image) moved to Red Hill in 1891. He was engaged in the butchering business for the next 26 years. Groff was heavily involved in various fraternal organizations and several banking institutions. He also served a number of terms on the Red Hill borough council. The postcard image below shows baker C. G. Kauffman standing next to the delivery wagon of his business, which he established in Red Hill by 1902. Kauffman came to America at about age 14 and later married into another baking family. He married Wilhelmina Kohler, whose family had bakeries in East Greenville and Lansdale. The Kauffmans discontinued their business and left Red Hill in 1932.

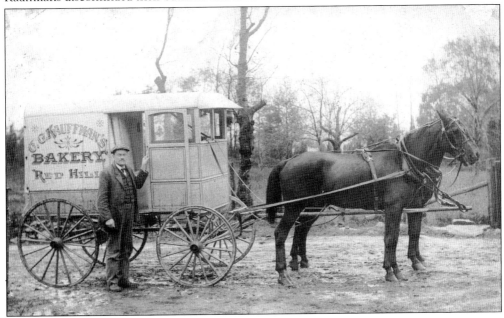

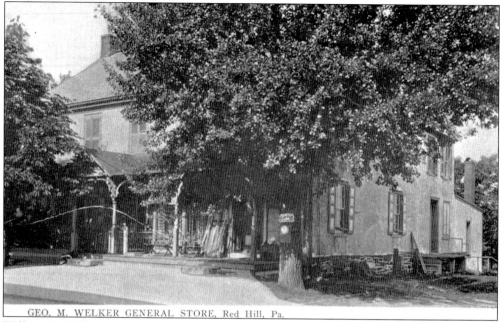

GEO. M. WELKER GENERAL STORE, Red Hill, Pa.

William A. Welker was one of the most esteemed and highly respected citizens of Red Hill. He held many important posts such as postmaster general, justice of the peace, and bank director, to name just a few. In 1874, he started a general store on Main Street. Later he was succeeded in the business by his son George M. Welker. Shown here is a c. 1920 postcard view of the store that carried a wide variety of merchandise. In 2007, the building is the site of the Main Street Inn restaurant.

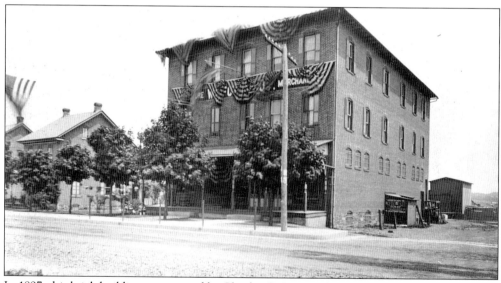

In 1897, this brick building was erected by Charles G. Heist at 400 Main Street. It was here that Heist opened his dry goods store. He operated the store until some time after 1905, at which time it was acquired by J. M. Shive. Following a short stint by the Shive family, the business was taken over by the Wilfong brothers, whose operation is pictured here about 1915. Subsequent tenants in the still-standing building have included a veterans organization and various banking institutions.

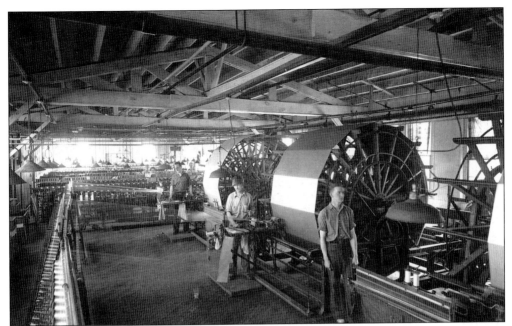

In this c. 1929 photograph, some of the inner workings of the Binze Silk Mill are seen. Commonly known as the Red Hill Silk Mill Company, the business was founded in 1922 along Washington Street between Seventh and Eight Streets. The mill's large building complex operated for two decades before it was sold to Rayflex, Inc. Subsequent tenants have included other manufacturers. The building remains today and is occupied by Mutual Industries, Inc.

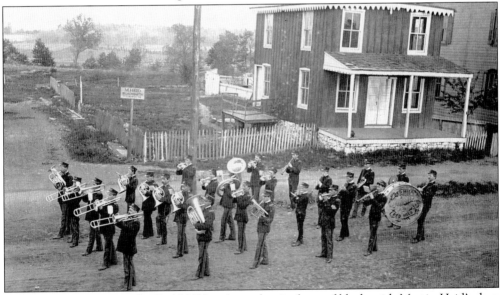

In this early-1900s view, the Red Hill band marches in front of blacksmith Martin Heid's shop at 328 Main Street. This distinguished organization is older than the borough itself. Formed on December 6, 1900, at the Red Hill Hotel, the band has a long record of achievement and has won many musical awards over the years. Currently it is the only remaining community band in the Upper Perkiomen Valley. It continues to be in much demand in the surrounding municipal areas during the summer concert season.

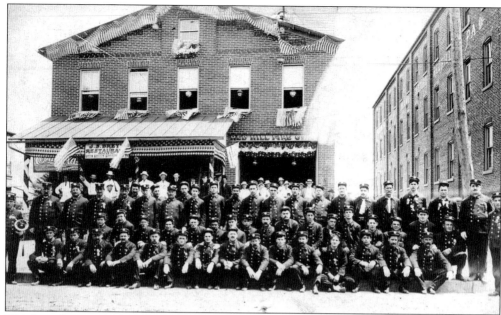

The formal organization of the Red Hill Fire Company was prompted by a disastrous fire that destroyed the famous horse bazaar next to the Red Hill Hotel on November 7, 1904. The fright of that fire, which nearly wiped out nearby homes, expedited the formation of a group of 62 volunteers who met at Lucian B. Miller's cigar factory on November 15, 1904. John P. Kline offered to build a firehouse complete with a bell tower and restaurant. This first firehouse directly on the north side of the Miller cigar factory was dedicated on August 5, 1905. In the above image, the firemen pose in front of their decorated firehouse. In the early years, the Hancock Fire Company of Norristown guided and helped establish the Red Hill organization, which was chartered as the Hancock Chemical Fire Engine Company of Red Hill. The first parade was held in Norristown, but soon after they were conducting their own parades in Red Hill. In the c. 1907 view below, the firemen parade along Main Street with their decorated wagons and equipment.

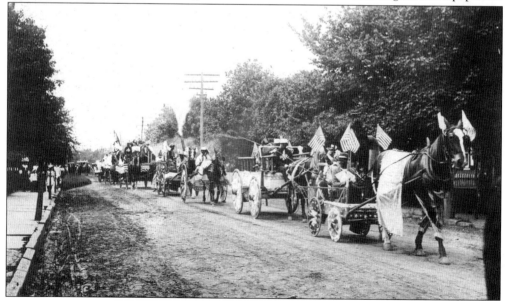

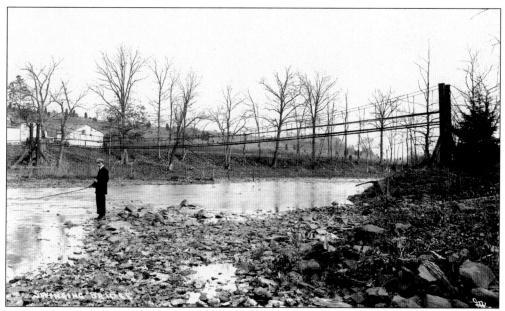

In this c. 1925 bucolic view, a local fisherman tries his luck near the swinging suspension bridge over the Perkiomen Creek. Dating back to 1880, the bridge was located on Swinging Bridge Road near the intersection of Red Hill Road and Knight Road. Pedestrians used the bridge to access various destinations on both the east and west sides of the creek. The construction of the Green Lane dam spelled the end of this landmark in the mid-1950s.

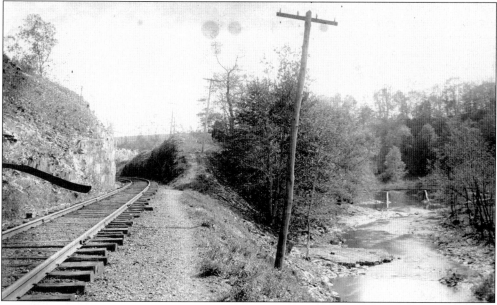

The Macoby Creek flows in a generally north-to-south direction from the eastern edge of Red Hill to Green Lane, where it joins the Perkiomen Creek. In this Macoby Valley area, the Perkiomen Railroad traveled a roughly parallel path to the banks of the Macoby Creek. In this early-20th-century view, the rail tracks are in close proximity to the creek. As a point of interest, it has been suggested that the word *Macoby* was a Native American term meaning "large turbid or reddish water."

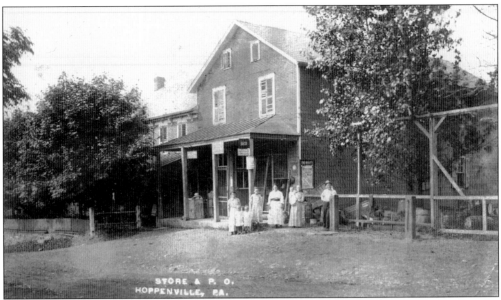

Hoppenville is located about half a mile east of Red Hill and lies near the dividing line for Upper Hanover and Marlborough Townships. The old village has not grown in size. The early Germanic settlers called it *die Schmaltzgasse* or "the Lard Road." Hoppenville had a post office from 1855 to 1928, and this is how it looked in the early 1900s. The store and post office were located on Geryville Pike near the intersection of Brinckman Road. The building still stands today as a private residence.

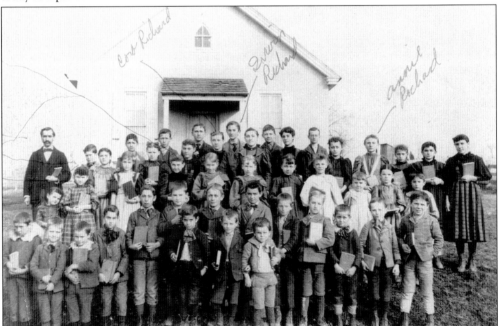

This public schoolhouse in Hoppenville was one of five different one-room schools located within the bounds of Marlborough Township in the late 1800s. This image was recorded in front of the school in 1894 and shows the teacher with the student body. The old stone school building was later remodeled and is currently a private residence.

Five

PENNSBURG

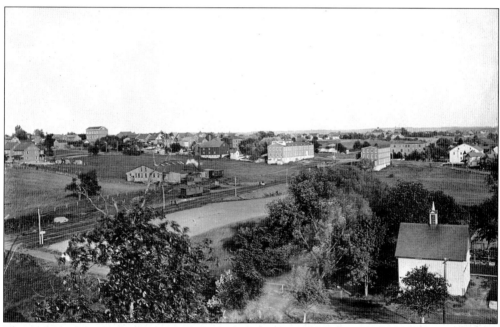

This is Pennsburg as it appeared in the early 1900s, viewed from near Seminary Street. The documented history of the area now known as Pennsburg dates back to about 1750, when Henry Heilig built a house here. Until 1840, the village was known as Heiligville and consisted of only a few houses, barns, a tavern, and a store. In 1843, the name changed to Pennsburg in honor of William Penn. Pennsburg was established as a borough in 1887. It was sometimes called the hub of the Perkiomen Valley since it is at the intersection of two roadways that had been known as the Green Lane and Goshenhoppen Turnpike and the Pottstown and Quakertown Highway.

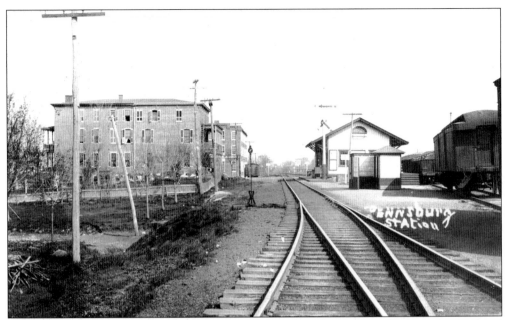

The photographer was headed in a northern direction when this image of the Pennsburg railroad station was recorded around 1909. That is the same direction in which the Perkiomen Railroad Company built the rail line that reached Pennsburg in 1874 and Allentown the following year. At left in this image is a side view of the American House Hotel. The rail station building is still standing and has had a variety of uses since closing in the mid-1960s.

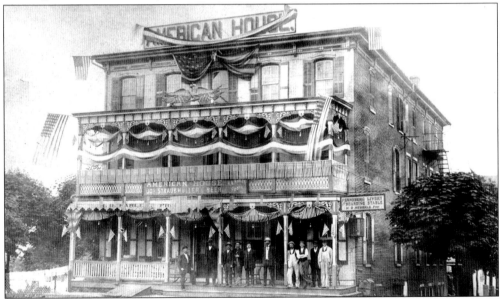

After the railroad reached Pennsburg in 1874, local developer Capt. Henry Dotts built a hotel right across the tracks at Fourth Street. In 1903, Horace Harley became the new owner and manager. Here the hotel is decorated for a parade in the early years of Harley's proprietorship. After Harley's death in 1924, the hotel operations were taken over by his daughter and son-in-law Eugene McLaughlin. Subsequent to McLaughlin's death in 1942, the hotel changed hands and presently is operated as a residential property.

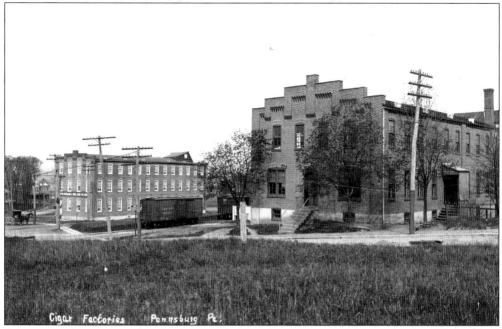

Across Fourth Street in this image are two cigar factories in Pennsburg. The building on the right is the Sulzberger Oppenheimer Company Ltd., which had home offices in Philadelphia. On the left is the Otto Eisenlohr and Sons Factory. Eisenlohr had been renting this building as a warehouse, but in March 1907 bought the building and operated it as a cigar box factory. This building was destroyed by fire in the 1960s. The still-standing Oppenheimer factory now serves as industrial space.

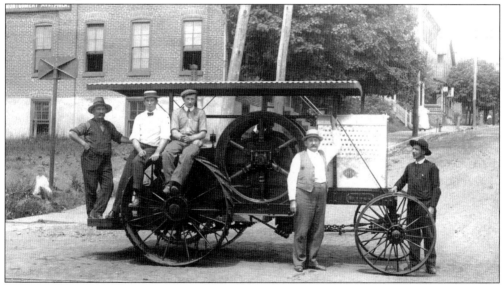

This image was recorded on Fourth Street in June 1911. These gentlemen proudly pose with this state-of-the-art tractor owned by William H. Tagert, who is shown at the controls on the back (left). Tagert was quite an entrepreneur at the time. He owned this rig plus other types of equipment that he leased out for use by companies or individuals. Records indicate that he employed his son Charlie to run a stone crusher at a nearby quarry.

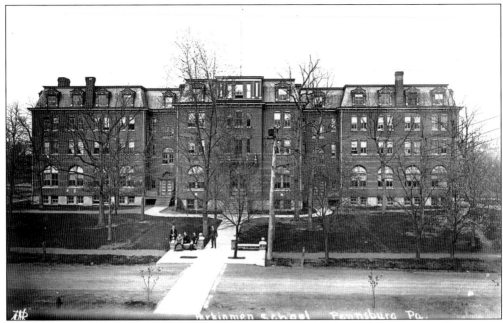

The Perkiomen Seminary was founded in Pennsburg in 1875 by Rev. C. S. Weiand of Pottstown. After about a decade of success, the school later struggled and actually closed due to lack of enrollment. In 1892, the property came under the ownership of the general conference of the Schwenkfelder Church and the management of Dr. O. S. Kriebel. Enrollment grew, and in 1896, a large main building was added to the original building. In 1905, the school built a modern gymnasium. In 1913, the school dedicated a public library with the help of a donation from Andrew Carnegie. In the *c.* 1909 photograph above is the main building, which is now known as Kriebel Hall. Below is an image of the Carnegie Library captured on the day it was dedicated; to the right is the gymnasium. These three buildings have seen changes and modernization over the years. Kriebel Hall, in particular, was rebuilt following a major fire in 1994. Now known as the Perkiomen School, it continues as a boarding and day school for college-bound male and female students from all over the region and the world.

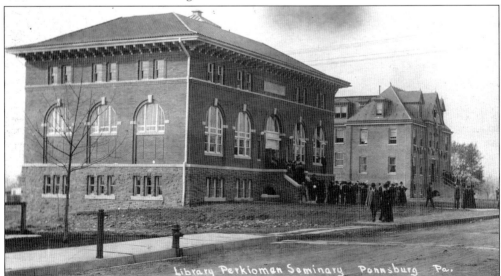

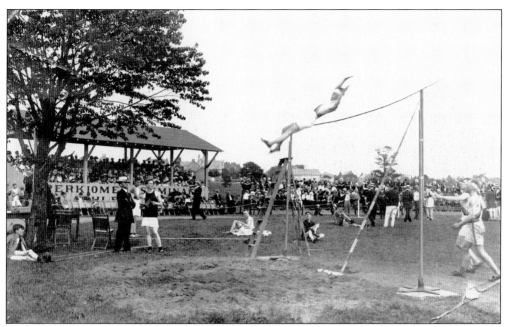

In 1912, the Perkiomen Seminary hosted a track meet on its north campus athletic field. Seen here is the large crowd gathered to watch the pole vault and other field events. During this period of time, the school was heavily involved in all kinds of athletic activities. The school fielded teams in football, baseball, basketball, and track. A review of the old records indicates that they played a variety of schools at both the high school and college level.

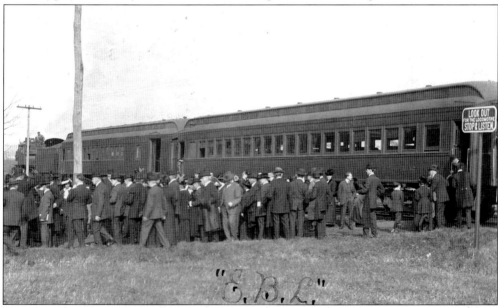

Day students at the Perkiomen Seminary who commuted by rail could board the trains at the school's rear entrance. The Perkiomen Railroad's tracks were a short distance from the main building, and the trains made special stops to accommodate the school. In this 1913 view, the special train used to carry dignitaries and visitors to the dedication of the Carnegie Library is seen.

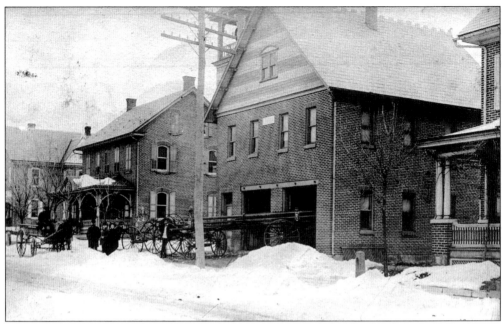

In these two 1907 winter scenes, the Pennsburg Fire Company "hose house," along with some of its early fire fighting equipment, is seen. The fire company began with just two pieces of equipment: a hose carriage and a ladder wagon, both of which were horse drawn. The borough purchased the equipment in the mid-1890s and housed it in a combination firehouse and town hall at 504 Main Street. After its formal incorporation in 1899, the members of the company chose Charles Q. Hillegass as their first fire chief. In 1919, the company began to purchase its first motorized equipment. Soon there was a need for enlarged facilities, and in the 1920s, the fire company razed the above original structure to make way for a larger three-bay firehouse that was completed in 1924.

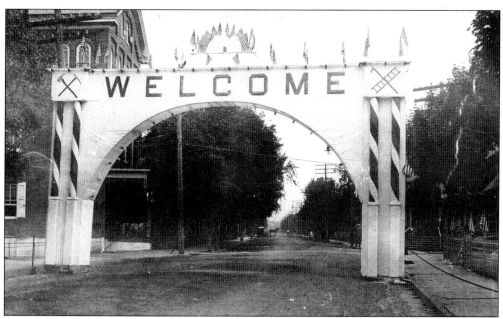

The Pennsburg Fire Company was at the heart of many community events. The firehouse served as a community center and was the scene of banquets, dances, fund-raising dinners, and sporting events. It was, however, the firemen's parades that generated the most excitement from the community. Great efforts were undertaken to make these celebrations a special event. In the above postcard view from 1909 is the great arch constructed near the town square at Fourth and Main Streets. The arch was a dramatic welcome to the visiting firemen and bands from nearby communities. In the lower postcard view from about the same time frame, the visiting firemen of the Norris Hose Company of Norristown march down Fourth Street and across the railroad tracks.

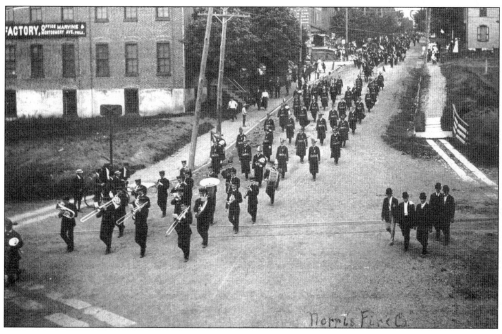

In 1871, Dr. James Mensch erected a building on the southwest corner of Fourth and Main Streets at Pennsburg's main square. From there he ran a hardware store and, in 1900, converted it to a drugstore. After 1903, the drugstore had a series of owners, including the Wehler and Levy families. The popular store, shown in this early-1900s view, also included a jewelry shop after 1916. In 1923, the former Mensch Drug Store was razed to make room for the Farmers National Bank, which was completed in 1926.

In 1875, the Odd Fellows organization built this large hall on the northwest corner at Pennsburg's main square. The original building is shown above as it appeared in 1907. A large three-story addition was added to the rear of the building in 1912. It was then the largest building in Pennsburg. In addition to the Odd Fellows, the building was home to the post office, the Farmers National Bank, and the Aurora Theatre, as well as other tenants. The building was torn down in 1967, and later the site became the Alma Mullen Park.

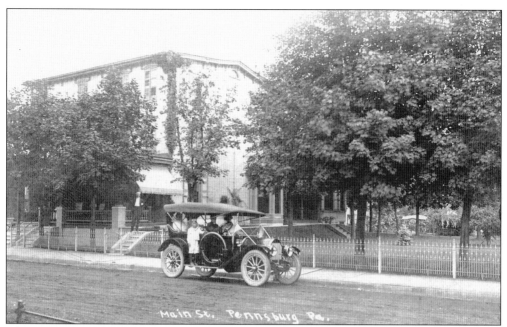

Above, an early automobile is seen traveling south on Main Street around 1911. Behind the automobile is a store that had a long history. Located on the southeast corner of the square, it was built in 1852 by Jacob Hillegass. Over the years, the business and the building passed through many hands and had various modifications and additions. In the early 1900s, the store operated as Gilbert and Hevener. In 1911, the partnership changed to Hevener and Shelly and continued for more than 40 years. In the photograph below is an interior view of the store soon after this new partnership formed. The gentleman standing second from the left is Fred Hevener; the gentleman standing second from the right is Walter Shelly. In most recent years, the store will be remembered as Reigner's Appliance and Television Store. The building was removed in 2006 to make way for a Dunkin' Donuts store.

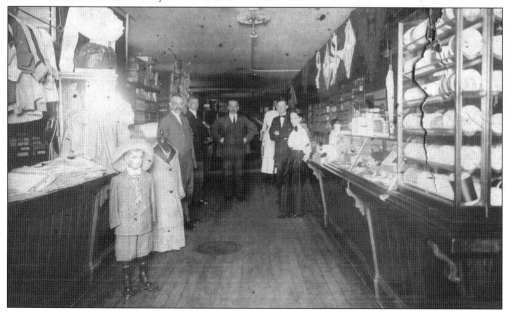

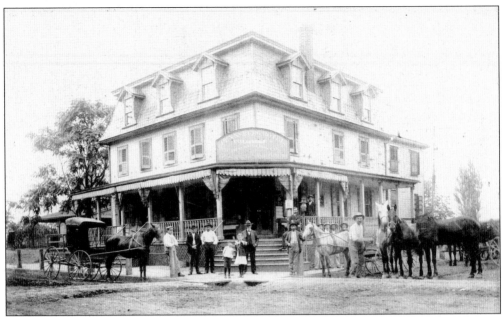

This Victorian structure graced the northeast corner of the town's square for nearly 115 years. The Pennsburg Hotel is shown above about the time it was acquired by one of its most notable owners. Charles A. Kneule bought the property from Herman Roth in 1904. This was the beginning of a long ownership by the Kneule family. When Charles died in 1930, his widow, Lucy, and later his daughter, Maude, continued operations until 1957. After a brief ownership by Ralph Wenner, the building was razed in 1961.

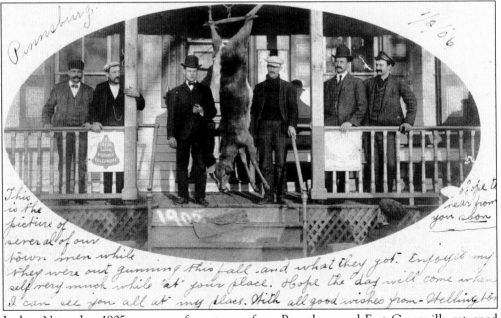

In late November 1905, a group of sportsmen from Pennsburg and East Greenville returned from Pike County with a large deer. Here they pose with their specimen on the porch of the Pennsburg Hotel. Several days later, Charles A. Kneule, proprietor of the hotel, served a free venison lunch to the people of the area.

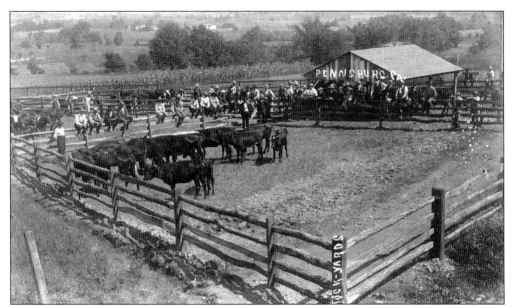

When Kneule acquired the Pennsburg Hotel, he established a stockyard at the rear of the hotel building. This c. 1907 image was likely recorded on a Monday, the usual sale day. When horses were being sold, the animals were paraded up and down Main Street in front of the hotel to exhibit them to potential buyers. The stockyard contributed greatly to the local economy by creating all kinds of local business.

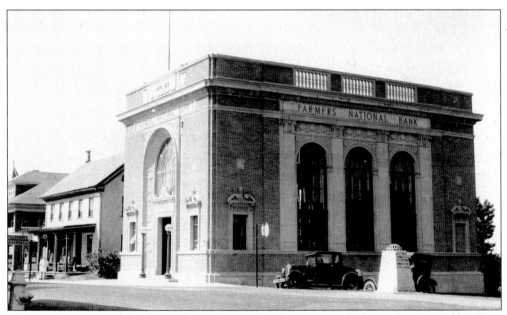

The Farmers National Bank was formed in 1876 and was originally housed in the Odd Fellows hall on the northwest corner of the town's square. This photograph from about 1931 shows the bank's new building that was erected on the southwest corner in 1926. The impressive classically designed building was constructed of brick and cast stone. Over the years, the building has been home to many different banking institutions.

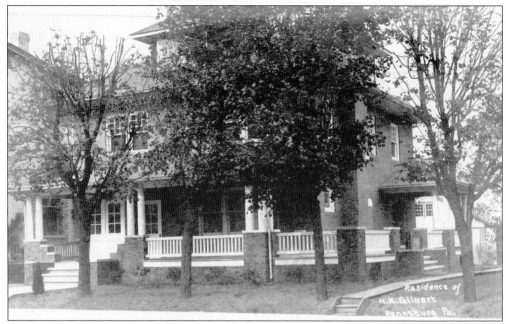

This image of the Michael K. Gilbert house was recorded soon after it was completed in 1914. Located at 404 Main Street, the house was right next door to the store where Gilbert had previously served as a partner in the firm of Gilbert and Hevener. When Gilbert died in 1928, the house was bought by the Dr. Charles Q. Hillegass family, which lived in the home for some years. This substantial building is currently serving as realtors' offices.

This beautiful Victorian structure, located on the corner of Fourth and Dotts Streets, was the early home of Dr. Charles Q. Hillegass. Dr. Hillegass was a local dentist who was the cofounder of the *Town and Country* newspaper. Today this house is used as rental residential property.

The *Town and Country* newspaper continues to be one of the true treasures of the Upper Perkiomen Valley. It all started on April 1, 1899, when Dr. Hillegass, a Pennsburg dentist, and Robert Singer, a clerk in a Pennsburg drugstore, issued their first edition of this weekly newspaper. While other early newspapers in the area used the German language, the *Town and Country*, in English, soon dominated the region. Above is the triangular plot at Fourth Street and Pottstown Avenue that Dr. Hillegass later purchased. On that spot, in 1913, he built the modern publishing plant and offices that were home to the newspaper for 73 years. Below is the brick and cast stone structure designed in the image of the New York Times building in Manhattan. Still printed today, the *Town and Country* newspaper editorial offices are now located in Red Hill. The current publisher and editor is local historian Larry Roeder, who continues the great tradition of this quality newspaper.

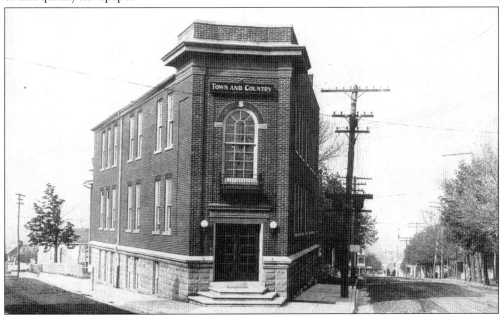

With the decline of cigar manufacturing, the textile industry filled this employment void in the Upper Perkiomen Valley. The largest of these enterprises was the Perkiomen Trunk and Bag Factory (at right) located on Pottstown Avenue between Green Alley and the railroad tracks. The company employed as many as 400 workers during peak periods. A major fire in December 1930 completely destroyed the factory. The fire ruins were later cleared, but it was not until 2007 that a credit union bank occupied the site.

Pictured near the southwest corner of the town square is Roth's Restaurant as it appeared around 1907. The restaurant operated in one-half of the building, which was considered to be one of the oldest in town. Roth ran a successful venture and served complete meals. The restaurant also featured a variety of confections, such as handmade candy. For 70 more years, the restaurant continued under numerous owners. In 1978, the building was razed to make room for a drive-in window for the adjoining bank.

In 1918, Joseph C. Ritter purchased Henry Stahsel's Oyster Shop located at 344 Main Street. Ritter became a real supporter of young people, and his restaurant was a favorite with the students at the Perkiomen Seminary. Many of the students enjoyed the trip "uptown" to indulge in Ritter's homemade ice cream. The wintry scene above shows the restaurant as it appeared on a postcard dated 1929. Readable under a magnifying glass is a sign by the door that proudly proclaims that the house specialty, oysters, was being served. Below is an interior photograph of the small but cozy dining room as it looked in 1929. When Ritter died in 1941, he willed his entire estate to Pauline Senske, who had been his longtime cook. She ran the restaurant for another six years before selling it. As a point of interest, book researcher Narona Kemmerer Gebert worked for Senske in 1942, and she reported that the restaurant interior looked the same as the view below.

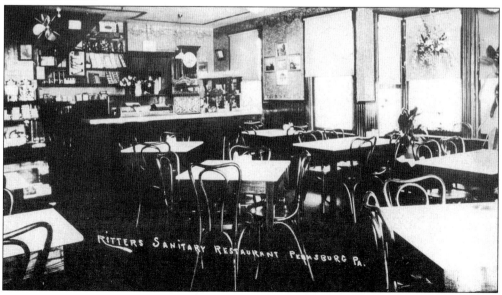

In the 1920s, the Main Street of Pennsburg was paved but only the center portion of the road bed was macadamized. This left wide, unpaved shoulders and a hump in the center of the road bed. Successive paving of the entire width of the roadbed caused a prominent hump in the center. When parking on Main Street in the 1930s and 1940s, the car rested at a pronounced tilt against the curb. Later road repairs corrected this condition, and today Pennsburg enjoys a wide, level road.

In 1906, during his spare moments, tollgate keeper William Boyer took a census of the widows and widowers in Pennsburg. As Boyer was a bachelor, it was intimated that he had designs on the widows. Be that as it may, he itemized 27 widows and 11 widowers in his census. Boyer tried to determine the cause for the disparity. Later Boyer was reported to begin a new census of the spinsters and the bachelors. One can only wonder if his curiosity was ever satisfied.

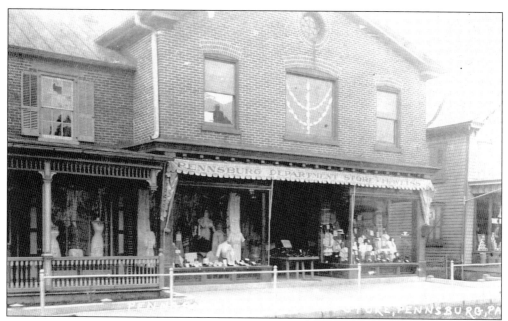

Harry Weiss started his department store on April 1, 1905, at 345 Main Street. Weiss launched the business in a rented storefront the day after he got married. About six months later, he bought the property and thereafter expanded it. This postcard image from 1913 shows the front of the store, which he called the Economy Store. In 1934, after Weiss abandoned business at this location, the building became home to an A&P grocery store. Recently the building has been used for retail and service businesses.

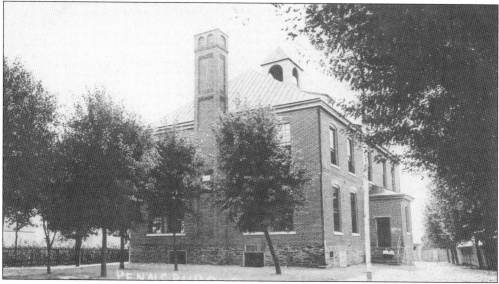

In 1890, a one-story public school building was built at 643 Main Street. Over the years, this Pennsburg School was gradually enlarged and the curriculum expanded. When this image was recorded about 1908, students were only able to receive one or two years of high school–level instruction. In 1924, a full four-year high school program was started. The site was used as a public school until 1975, after which it served a multitude of community functions. It is currently an apartment complex.

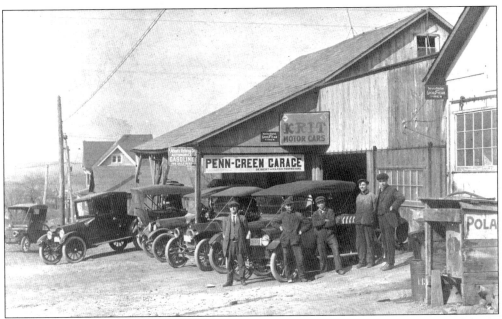

In 1905, local plumber Victor H. Steckel was the first Pennsburg resident to own an automobile. As the popularity of the automobile increased, new opportunities were seized by local entrepreneurs. In this c. 1917 view is the Penn-Green Garage located on west Third Street, between Main Street and the first alley. Proprietors Diebert and Marsh provided all kinds of services and sold new vehicles. One sign on the wall behind the men indicates that a "K-R-I-T Motor Car" could be bought for $900.

The silk mill industry began in Pennsburg around the beginning of the 20th century, when the Schantz brothers of East Greenville, along with a Pennsburg construction company, built this factory on Seminary Street. The mill shown here about 1908 wove silk ribbon and over time passed through different ownerships, including the Eureka Silk Company, Queen City Silk Company, Bethlehem Silk Company, and later Buffalo Label Works, Inc. Today the building is used for apartments.

In 1892, the Union Sunday School students posed for this photograph in front of the Pennsburg Reformed Church. Originally built in 1854–1855 as a Union church with the Pennsburg Lutheran Congregation, the building has seen many renovations over time. In 1901, a 22-foot-by-46-foot addition was made to the front and a bell tower was added. This beautiful church building still graces South Main Street near Eighth Street.

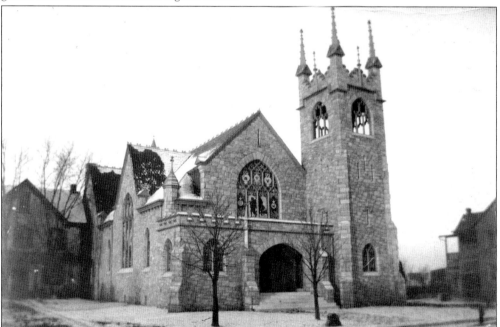

After breaking away from the Union Church (above), St. Mark's Lutheran congregation started building this church in 1898 at the corner of Front and Main Streets in Pennsburg. The church was dedicated on June 3, 1900. A bell tower was installed in 1902, and the above image was recorded about 1907. The original property mansion (at left) was removed from the south side of the church in 1930. Major interior renovations were performed in 1929, and the addition of the educational building was completed in 1960.

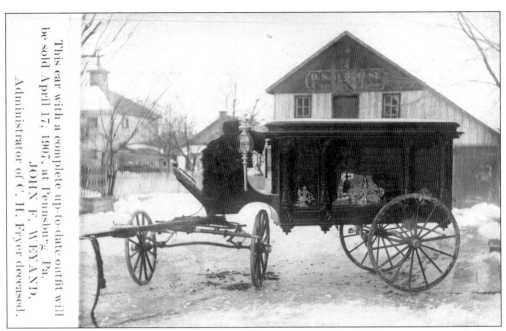

Clayton H. Fryer was one of the most talented contractors in the Perkiomen region. He built many important local structures. Fryer also served as undertaker but died in 1907, only two years after embarking on his new career. In April 1907, his estate auction held in Pennsburg included this excellent hearse. There were at least 20 undertakers present from as far away as New Jersey. After spirited bidding, the hearse sold to William Hangen of Steinsburg for $680.

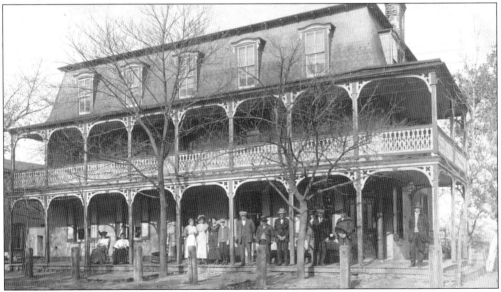

This hotel was located in Perkiomen Heights, at Pottstown Highway (Route 663) and Kutztown Road. When this postcard image was captured around 1911, the business was being operated by Jonas Haring, who had been the owner since 1879. In 1912, Haring sold the hotel to Henry Renninger, who two years later sold it to Amandus B. Kline. The Klines had the business for 56 years. It was sold to new owners in 1971 and operated for a short time before the building was severely damaged by fire and razed.

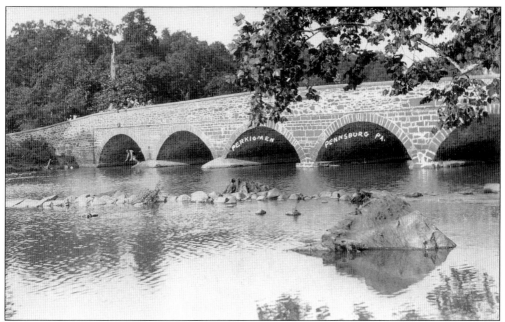

The Perkiomen Creek in the area of Mensch's bridge and dam was a popular recreational magnet in the early 1900s. Mensch's bridge and dam was located between Mensch Dam Road and Kline Road on the southwest side of Pennsburg. Situated on one of the most prominent curves in the Perkiomen Creek, it was an area that was sought out by both summer and winter sports enthusiasts. In the postcard view above, children swim between the dam and the bridge. The large rocks that dotted the creek both above and below the dam provide the perfect pad for diving or just soaking up the sun. Summertime also brought out boating and fishing enthusiasts. In the photograph below, local folks enjoy ice-skating on the frozen Perkiomen Creek. Skating at this location was a particularly popular pastime with the students from the Perkiomen Seminary. This area of the Perkiomen Creek is now under the surface of the reservoir.

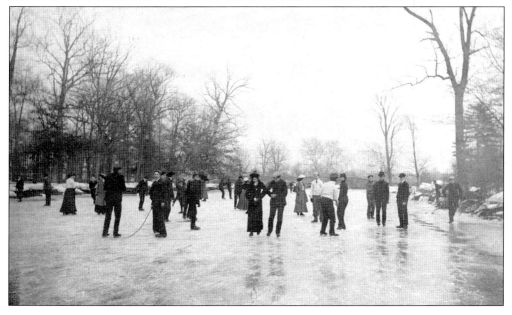

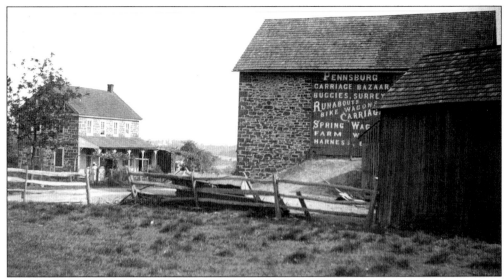

This c. 1906 photograph shows the signage on the side of the storage barn for the Pennsburg Carriage Bazaar. Founded in 1889, and highly successful until the end of the horse-and-buggy days, the bazaar was located on Pottstown Highway (Route 663) near Kings Road. Proprietor J. F. Weyand was an aggressive entrepreneur who advertised heavily and challenged other local carriage shops for the lion's share of the business. Weyand advertised buggies from $45 to $95 and a harness with nickel trimmings at $14.

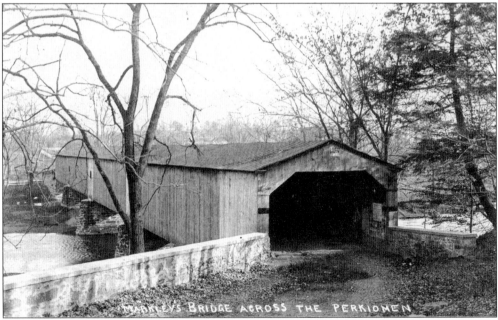

For 121 years, Markley's Bridge helped travelers cross the Perkiomen Creek at Philadelphia-Kutztown Road in Upper Hanover Township. The bridge was built in 1835 and named after the Markley family, which ran a nearby mill. Sometimes known as the "kissing bridge," it spanned 301 feet and sat upon four red stone piers. It was the last covered bridge in Montgomery County when it was demolished in 1956 due to the coming of the Philadelphia Suburban Water Company's reservoir.

Six
EAST GREENVILLE

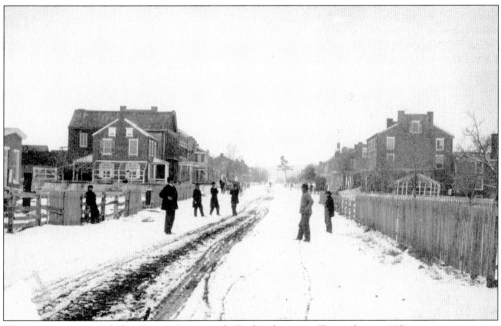

The construction of the Green Lane and Goshenhoppen Turnpike in 1851 gave impetus to the emerging village of East Greenville. Historians have reported that the name Greenville was applied around 1852 as a result of a prominent tall pine tree located on the north side of Main Street. The "East" portion of the name was later added to differentiate the town from another Greenville in the western part of Pennsylvania. East Greenville was incorporated as a borough in 1875. In this early image of Main Street is the famous pine tree for which the borough was named.

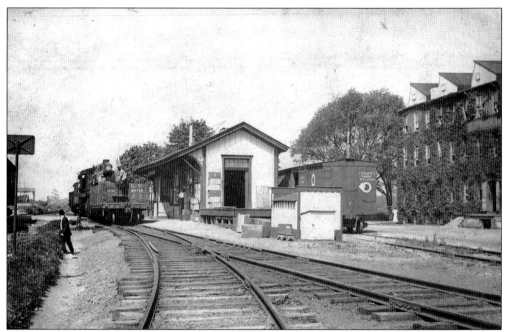

This photograph from 1910 shows two important symbols of East Greenville's development. Railroad services began in 1875, and this station house located near Fourth and Railroad Streets was a beehive of activity. Shown at right is the Otto Eisenlohr Cigar Factory that provided employment for hundreds of local people during the first two decades of the new century. Similar railroad sidings were available to many other nearby industries.

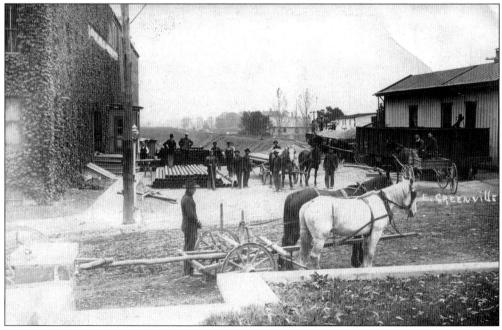

In this 1906 view of the rail siding at the station house, long lengths of pipe are being loaded onto pipe carriages. This pipe would later be used by the newly formed East Greenville acetylene gas plant to install a gas delivery system for the borough.

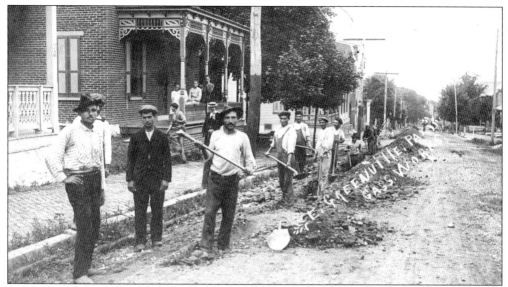

In August 1906, most of the area's labor force was being utilized on farms or in many of the local industries. The Acetylene Gas and Construction Company made a determination to bring in outside labor in order to install the gas piping in the streets. Here a group of Italian laborers dig pipe trenches on Fourth Street. Each laborer was paid $1.65 for the day's work.

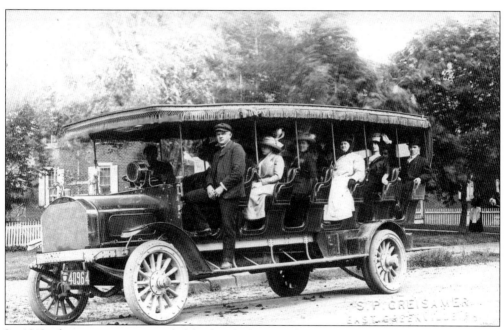

In 1912, this image was recorded by local photographer S. P. Greisamer. It was then that motorized bus service to East Greenville was first introduced. Open-air Mack passenger vehicles operated between many points in the Upper Perkiomen Valley and Boyertown. This service and the company failed in just a few years when it attempted to expand the route to Collegeville.

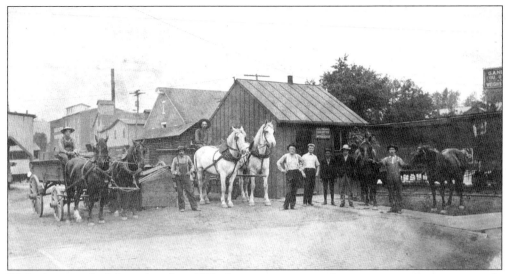

With the arrival of the railroad in 1875, the transportation of important products was greatly improved. The railroad allowed coal from upstate mines to be efficiently shipped into the region. There were a few lumber, coal, and feed yards that grew up between Third and Fourth Streets. Shown here around 1908 are workers at the G. A. Nevins coal offices and weigh scales.

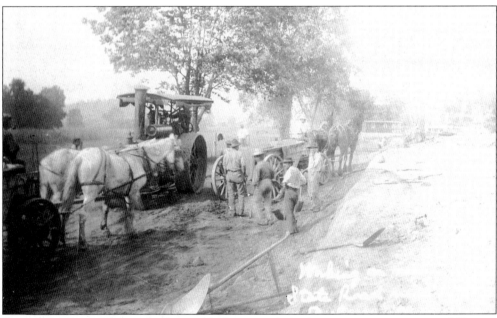

Early in the automobile age, the demand for better roads was becoming more pronounced. Despite complaints from farmers, muddy roads had been the rule for generations. In this postcard sent in August 1908, improvements are being made to State Road near East Greenville. In 1911, with the establishment of the state highway department, shared road maintenance costs accelerated local road improvements.

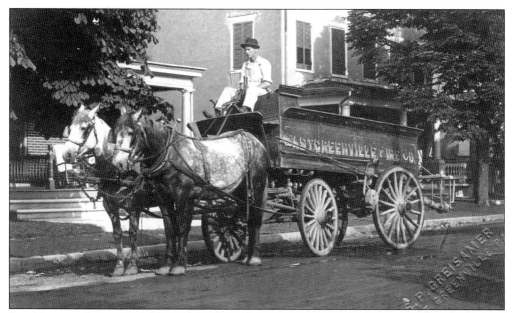

In addition to being available to fight fires, this apparatus was used on a regular basis for the purpose of improving daily life in the borough of East Greenville. Shown in this c. 1908 photograph is the East Greenville Fire Company tank wagon, rigged and ready to go. The wagon was used as a water sprinkler on the borough's dust-covered roads.

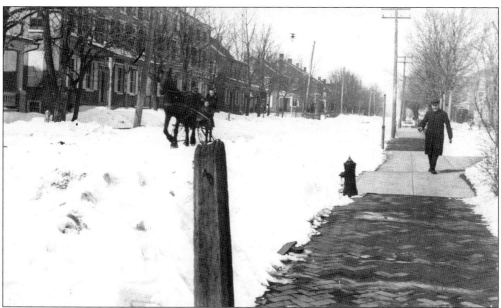

Snowplows did not exist in 1907, so if the streets were to be cleared, it had to be done with shovels, and lots of grunts and groans. Typically the folks stopped after they had shoveled their brick or concrete sidewalks. After a bad snowstorm, the only way to quickly navigate the streets was by means of a horse and sleigh.

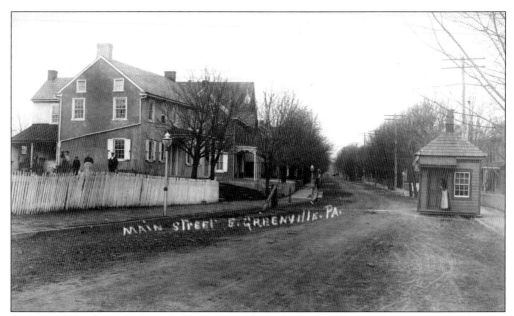

After the Green Lane and Goshenhoppen turnpike was completed in 1851, tollgates were built to collect tolls for the upkeep of the road. In the above *c.* 1907 image, captured along the south side of Main Street, a tollgate is situated across the street from the George Seasholtz farmhouse. In the image below is the same tollgate a few years later, and this view is of the buildings on the other side of the street. The large three-story brick building at center is Young's Grocery and Provision Store. Fred Young built his grocery store across the street from his gray stone duplex house around 1910. Young was succeeded by two other grocers, a Rexall Drug Store, and later by Bauman Cleaners, which occupied the site for more than 50 years.

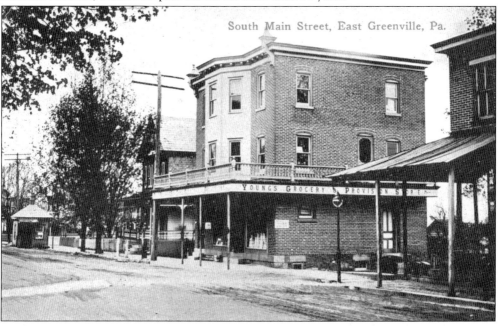

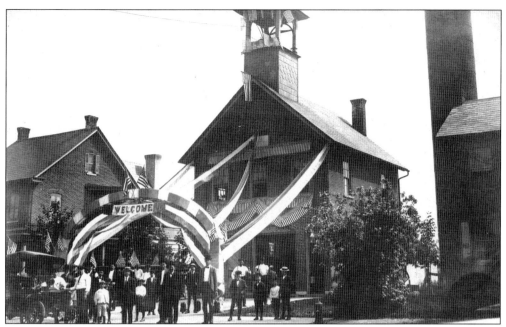

On May 25, 1900, the East Greenville Fire Company was officially chartered. Soon a fire hall in the 400 block of Main Street was erected, along with a 100-foot-tall standpipe water tower. A hose carriage and other fire equipment at that time was either hand or horse drawn. Above the roofline of the firehouse was an open tower, which hung a large steel hoop chime. The chime was made from the wheel of a steam locomotive. A sledgehammer striker was used to summon firemen. In the above c. 1908 image, the firehouse is all decked out for visiting firemen. The first motorized apparatus was purchased in 1924 at a cost of $10,750. This Stutz pumper is pictured below near the banks of the Perkiomen Creek. In 1926, the company moved to larger quarters at Fourth and Main Streets. In 1957, the company moved to its current location at Fourth and Washington Streets. The locomotive wheel chime is displayed in front of this current firehouse.

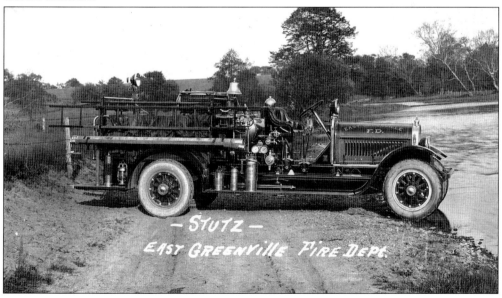

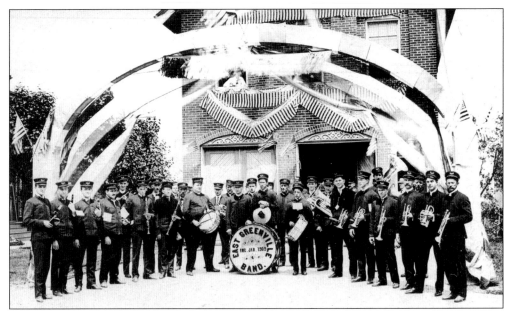

The East Greenville Band lined up in front of the East Greenville firehouse around 1920. The sign on the drum states that the band was incorporated in January 1909, but this organization had a long squabbling history that dates back to 1853. It started as the Citizens Band and over the years changed names and musicians too many times to enumerate. As the East Greenville Band, it seemed to prosper and even bought its own building in 1923 at 236 Main Street. Finally, in 1955, the organization disbanded.

Around 1875, A. E. Kurtz built a tinsmith shop at 320 Main Street. Situated directly across the street from the bank, the shop installed tin roofs and made cooking ware and sold cook stoves and parlor heaters. The business was later taken over by son Calvin, who with his son Clarence continued the business. Seen in the 1906 image above, this establishment lasted for 50 years. The building in recent years has served as a hair and nail salon.

Above is the Perkiomen National Bank as it appeared in the 1940s. This prominent building located at Main and Bank Streets was a familiar East Greenville sight for nearly a century. The bank had actually been founded in Green Lane in 1874, but was reorganized several years later. In September 1876, a contract was made with Jonathan B. Wolf to construct this bank building in East Greenville for the sum of $3,340. In December 1898, the bank was formally chartered at its new location. Below is an image of the bank interior as it looked in the early decades of the 1900s. The bank was progressive for its time, and in 1954, a two-room addition was added to the building. In December 1960, the bank merged with the Industrial Valley Bank and Trust Company. In June 1967, the old bank building was razed and a new building was erected. It is currently a Univest bank.

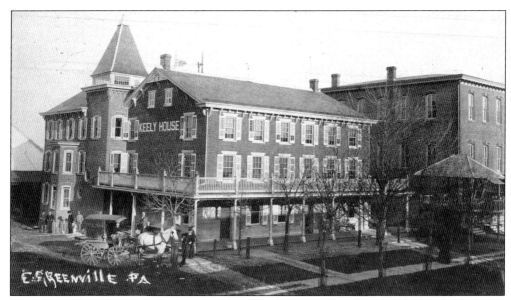

One of two East Greenville hotels, the Keely House was in its prime around 1895, when this photograph was taken at Main and Bank Streets. Originally built about 1852, the successful hotel saw changes to its physical structure and a series of owners over time. A dramatic change occurred in 1942, when the fraternal Order of Owls Nest 1302 purchased the property and converted the main building into a club room with dining facilities. This landmark continues as the Owls Nest.

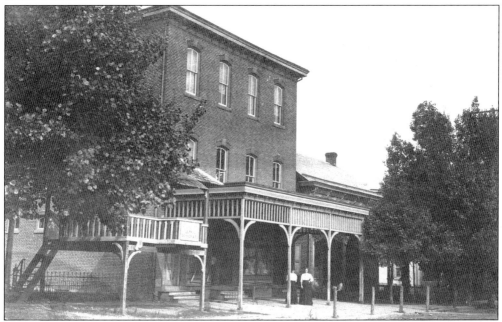

The Knights of Pythias lodge was organized in East Greenville in 1870. In 1889, this three-story building at 307 Main Street was erected. The building had room for several businesses as well as large meeting rooms; nevertheless, in 1916, the organization abandoned this building for larger quarters. The bandstand that belonged to the Keely House Hotel next door is seen in 1908. The Knights of Pythias building stands today as rental space and a residence.

Alfred Schantz was instrumental in the building of this silk mill on Bank Street around 1898. This mill manufactured ribbon products and later added broad silk to its line. Some time later, this mill became known as the Columbia Silk Mill and operated until 1950. In 1985, the building was severely damaged by fire and later razed.

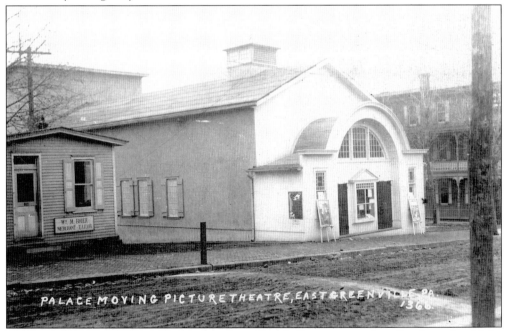

The Palace Moving Picture Theatre stood on Fourth Street across the alley from the Globe Hotel. Seen here soon after it was built in 1910, the theater entertained patrons with both motion pictures and live stage performances. The theater was not successful and closed in about five years. The building was used briefly for clothing manufacturing, and in 1936, the front section was demolished. In 2007, the rear section is used as apartment space.

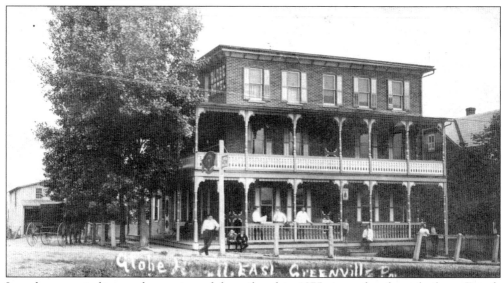

In order to capitalize on the coming of the railroad in 1875, a new hotel was built on Fourth Street close to the railroad station. It was first known as Kline's Hotel, and then it was owned by Jacob Reiff in the early 1900s. By the time the above postcard image was captured about 1907, it had become the Globe Hotel. The hotel had a livery stable on the south side. The stable was later used for auction sales and then a machine shop before it was demolished in 1956 to make room for a parking lot. The hotel had all the amenities associated with a first-class establishment. The interior view below shows a group of gentlemen standing at a well-stocked bar. The hotel also had a high-class barbershop operated by W. L. Loller, who had previously operated shops in the Hotel Astor and the Bellevue Stratford. In 1955, the Graber family turned the property into a fine restaurant. After 1990, a new business owner operated it as a bed-and-breakfast with a restaurant serving Italian cuisine.

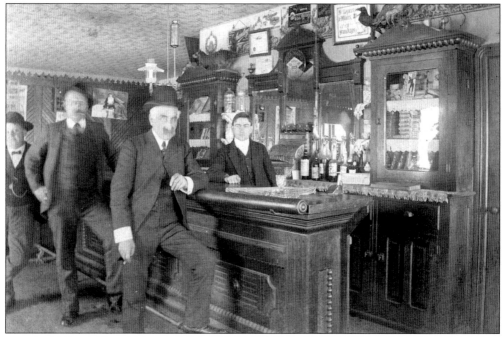

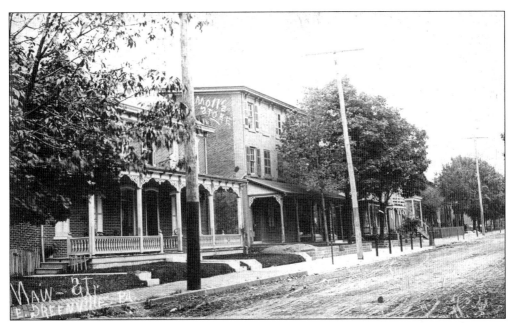

In these two postcard views are the exterior and interior of a Main Street store with over a century of retail selling. The building was erected at 314 Main Street some time after the mid-1800s by real estate developer Henry Dotts. William Kehl was one of the first merchants. The two photographs here were taken about 1908 during the tenure of Frank Moll, who had the store from 1905 to 1933. As can be seen from the interior shot, Moll sold all manner of dry goods and seemed to specialize in clothing, as indicated by many advertisements placed in the *Town and Country* newspaper. One such advertisement for suits and overcoats proclaimed, "Good cloth doesn't make good clothing—good tailoring does." After 1933, the store came into the hands of Russell Trexler and the emphasis changed to hardware sales. The store operated for many more years as Trexler's Hardware. The building is currently used as a café and a school of self defense.

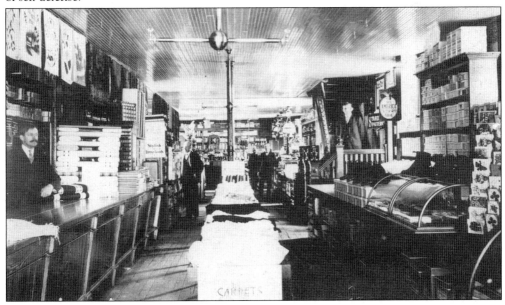

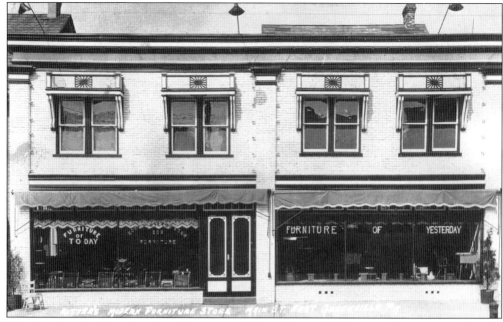

The furniture business has long been part of East Greenville's history. Some time after the mid-1800s, Daniel Dimmig and Edwin Steltz built this store in the 200 block of Main Street. Steltz was a dealer in all kinds of furniture and repair. When this postcard image was recorded around 1921, the proprietor was Robert Ritter. Ritter's son, Victor, followed him in the business, which continued for many years. Today the building is the home of the Main Street Plaza.

Prior to the coming of supermarkets, the corner grocer was the main source for the family's food supplies. Shown here is the George A. Huber grocery store at Second and Jefferson Streets soon after it opened in 1908. Huber ran the store for 38 years until his death in 1946. His son Arthur then kept the store operational for several years; it was later continued under a new owner and is now a residence.

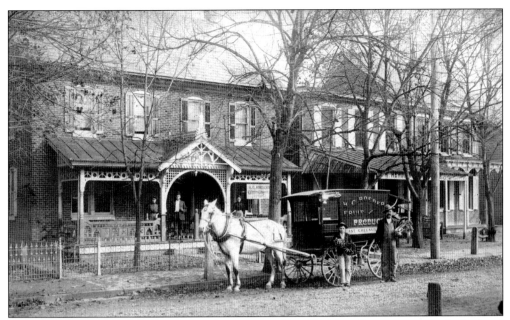

Pictured here in 1908 is Henry C. Roeder in front of his 211 Main Street store. By the looks of things, he took great pride in his business, which sold fruit and produce. On November 18, 1911, the *Town and Country* newspaper reported the following: "Green grocer, Henry C. Roeder this week went over his route with a newly painted wagon and a finely polished harness. The outfit looked like new and everybody who saw it commented on its neat appearance."

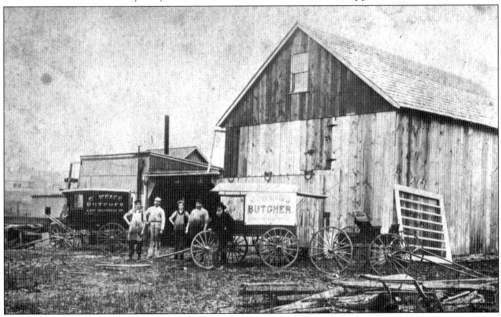

Butcher Emil Weiss of Pennsburg relocated to East Greenville in 1903. After taking on partner Samuel Dierolf of East Greenville, this butcher shop complex was erected east of the borough near the banks of the Macoby Creek. The business also maintained a retail market outlet alongside the bakery on Main Street. About 1928, the meat market was taken over by Allen R. Schantz. Currently both sites are private residences.

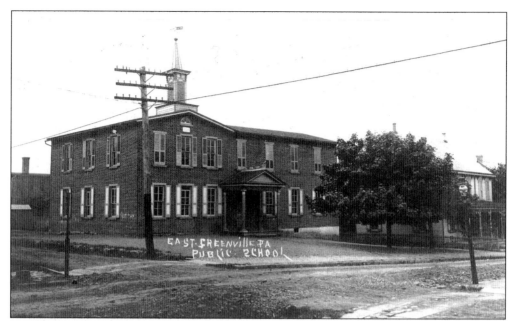

In 1875, the Greenville Literary Society erected a two-story elementary school along Third Street on the west side of Main Street. On June 7, 1876, the first public school board was organized. Building improvements were made to the elementary school in 1889, when two rooms were added. In 1902, the school board added two more rooms. Shown above is the East Greenville Elementary School as it appeared in 1910. Decades later, the school was removed, and today the site is a grassy lot.

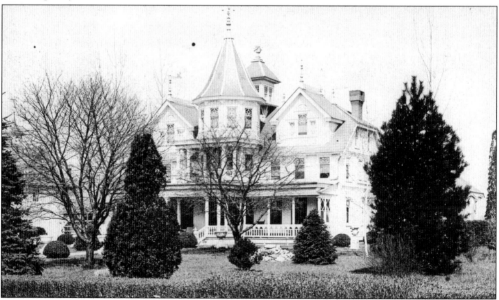

Around the beginning of the 20th century, Samuel Althouse built this palatial mansion at the corner of Fourth and State Streets. Many visitors to East Greenville would come to see this masterpiece structure. During the early decades, Althouse lived here with his family and manufactured and sold patent medicines from his dispensary on the grounds. The mansion was eventually razed in the 1950s.

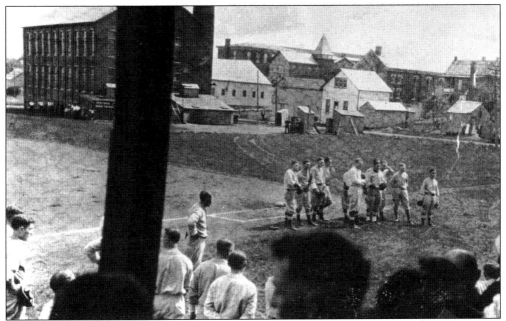

As early as 1885, baseball teams played in a ballpark below Third Street on the west side of Main Street. Then, in 1910, this ballpark was opened on the east side, near Fourth and Washington Streets. This view from 1929 is looking through the spectator's screen toward right center field. Managers fielded teams until about 1950, when the East Penn League disbanded. In 1960, this East Greenville playing field became home to the B and H Market.

The photographer's caption on this eye-popping c. 1915 photograph simply identifies the location as the "Bieler's Residence." There were various branches of the Bieler family involved in agricultural-related businesses at the time. More than likely, these gigantic elephant ear plants were grown on the Henry Bieler farm. One thing is for sure, somebody named Bieler had a very green thumb.

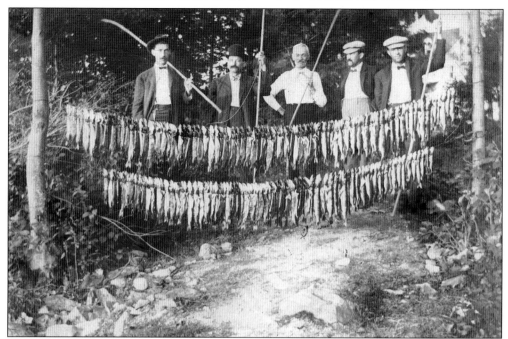

Early settlers in the Perkiomen Valley are reported to have caught shad in the Perkiomen Creek. In 1905, the fishing in the "Perki" was still pretty good, with farmers reporting quantities of bass, catfish, and carp being caught. That was not good enough for Issac Raudenbush, Frank Snyder, and Oswin and Ambrose Seasholtz of the East Greenville Fishing Club. They spent one week fishing in Pike County and returned to show off 160 pickerel. Some of them were of enormous size.

In the first decade of the 1900s, most young ladies in East Greenville had a doll. It was by far the most popular toy for girls. Posing here in front of the fire company water tower on Main Street is a large group of girls with their dollies and all sorts of carriages and accessories.

Immediately after the end of World War I, U.S. pilot Howard Dimmig, East Greenville native and Pennsylvania State University graduate, visited in his army Jenny airplane. The local pilot, home on furlough, created quite a bit of excitement when he landed in Heimbach's field near Third and State Streets. This field later became the site of a housing development.

The Ebenezer Evangelical Congregation built a church in 1895 along the south side of Main Street. The small congregation had formerly been a part of the East Greenville-Hosensack Charge. In 1930, the original small structure was demolished and replaced by this larger church at the same site. It is now home to the Peace Mennonite Church of East Greenville.

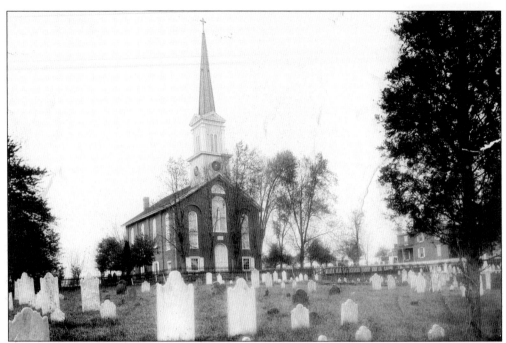

The Reformed Congregation of the New Goshenhoppen Church dates back to before 1700. The church building shown here is the third structure erected. This beautiful Victorian brick church was constructed in 1857. It was built to accommodate a Sunday school on the lower level and a sanctuary on the main level. The cemetery is the oldest in the Upper Perkiomen Valley. Many early graves are marked by hand-carved stones.

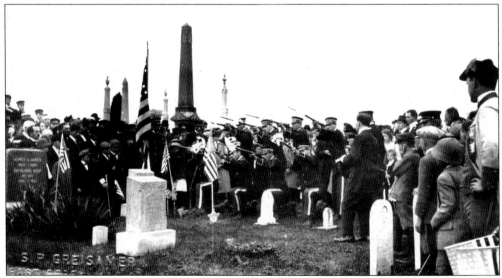

The annual Memorial Day observance at local cemeteries was begun in 1906, when local firemen first decided to honor soldiers of past wars. The ceremonies included parades to the cemeteries as well as flag and floral decorations for the grave sites. Ministers and scholars were called upon to pay tribute to fallen heroes, which in some cases were firemen. In this 1920s image by East Greenville photographer S. P. Greisamer is a contingent of firemen ready to fire off a volley at the New Goshenhoppen Cemetery.

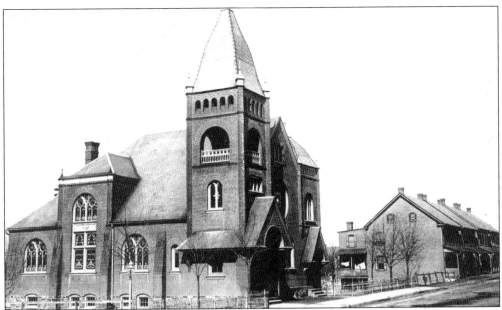

In 1894, the congregation of the New Goshenhoppen Church built St. John's Chapel on Jefferson Street. The chapel was intended to serve as an auxiliary worship location and a supplement for other parish needs. The distinctive chapel with its three-story bell tower is shown here as it appeared in 1909. In April 1979, it was completely destroyed by fire. It was eventually razed to make room for houses, but the bell was moved from the tower to a place of honor at the New Goshenhoppen Church.

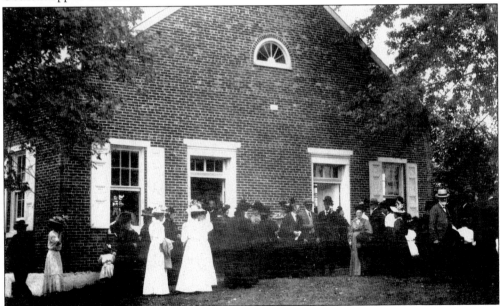

Before 1800, Balthasar Kraus Jr. transferred land to the Schwenkfelder congregation. The congregation later built a meeting house along Kraussdale Road, east of East Greenville. In 1875, they replaced the original structure with the brick meetinghouse shown in this 1908 photograph. It was used for regular service until a new Schwenkfelder church was dedicated at Palm in 1911. The Kraussdale meetinghouse is still used for special services.

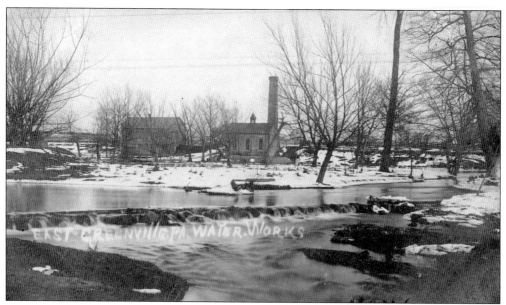

In the winter of 1906, the East Greenville pump house and standpipe was part of this wintry scene along the Perkiomen Creek. The borough erected this water plant facility in 1894. Located about one mile on the west side of the borough, the operation was the most modern for its time. In 1938, with the requirements of an increased population, a new plant was built that included an ellipsoidal-shaped storage tank. Today a more modern plant exists on the site. The old pump house still stands, less the standpipe.

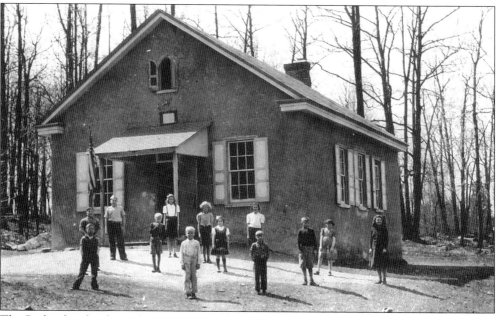

The Bethesda school stood on the corner of Kutztown and Township Woods Roads in Upper Hanover Township. The beginning of this one-room school dates back to 1854 when seven other one-room schools were built in the township. Shown here in 1942 is the second, larger building erected on the site in 1863. Lack of pupils in the immediate area forced the school's closing in 1943. Today the converted building is a residence.

Seven
PALM

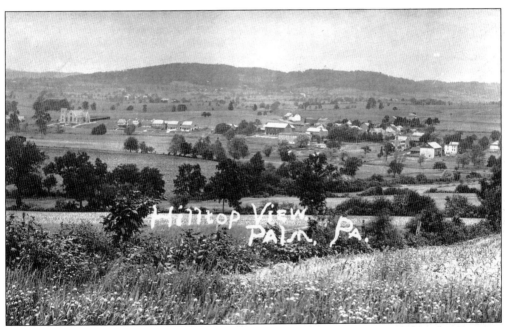

The village of Palm is located at the northernmost corner of Montgomery County. In 1866, the village received its first post office. By 1875, with the arrival of the Perkiomen Railroad, the village became more significant. In spite of its small size, Palm became an active place for the shipping of large quantities of harvested ice and agricultural products. Other businesses included a well-stocked store, a large hotel, and a glove factory. Later operations at Millside Park invited large numbers of visitors to the area during the fair-weather months. This c. 1914 image is a hilltop view of Palm.

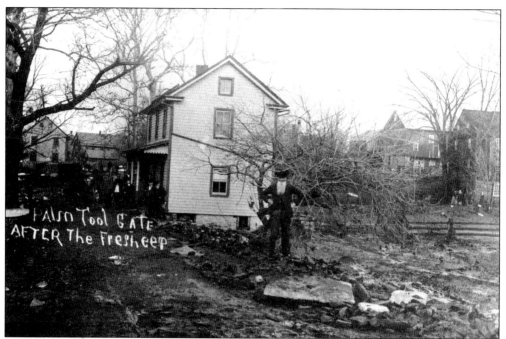

Pictured here is a Palm image recorded about 1901. Note the publisher's caption: "Palm Tool Gate after the Fresheet." *Toll* is misspelled, as well as the English word *freshet*, meaning flood; so this the Palm tollhouse after a flood. This house was originally built on the east side of the Green Lane and Goshenhoppen Turnpike Bridge across the Hosensack Creek. In 1902, it was moved to the west side of the bridge by local contractor Clayton H. Fryer. Although modified and enlarged, the structure still stands.

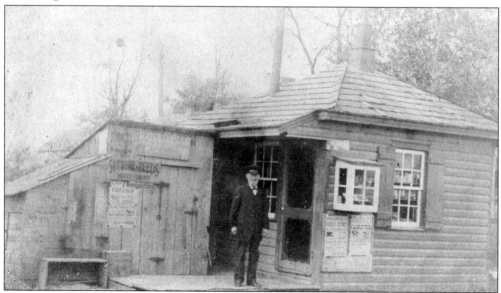

Turnpike tollgates were spaced about a mile apart, and this one was located above Palm, near Toll Gate Road. The Green Lane and Goshenhoppen Turnpike (Gravel Pike) continued until its junction was Route 100, but this was the last tollgate in Montgomery County. Tolls were collected until about 1919, when the state purchased this private road.

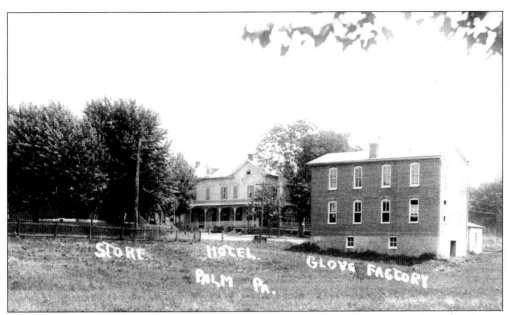

In 1908, the store (behind the trees), hotel, and glove factory were the center of activity for the village of Palm. Situated along the Green Lane and Goshenhoppen Turnpike (Gravel Pike), it was a convenient short walk to the railroad station for hotel guests and glove factory workers.

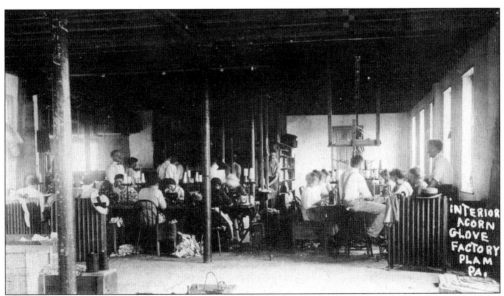

This view is of the interior of the Acorn Glove Factory soon after it began production in 1907. Brothers and co-owners Allen and Henry Stauffer built the factory to house their eight machines, producing 50 pairs of gloves a day. There were numerous additions to this factory building, which continued to produce gloves until about 1957. This now large building is currently home to several businesses.

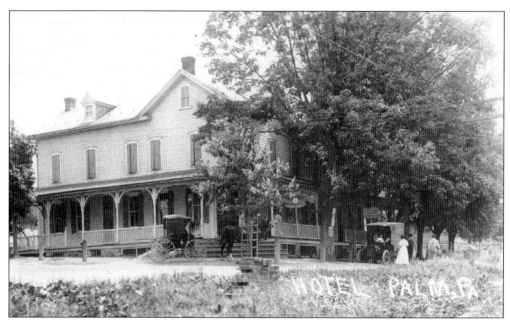

The postcard above shows the Palm Hotel as it appeared around 1910. It was the only hotel in Palm and at this time was operated by proprietor I. G. Rahn. The Palm Hotel reported that city boarders frequently filled the rooms to capacity. The hotel also boarded migrant and seasonal workers, including the large number needed for ice harvesting. Below is an interior view of the dining room of the hotel at a somewhat later period. The hotel's facilities were a gathering place for all sorts of private parties as well as public social and political events. The business continues to operate as a restaurant under the name of Hannah's Hanover Inn.

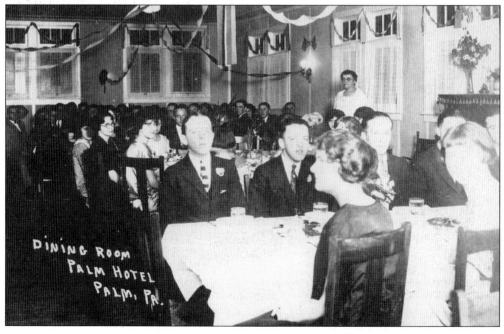

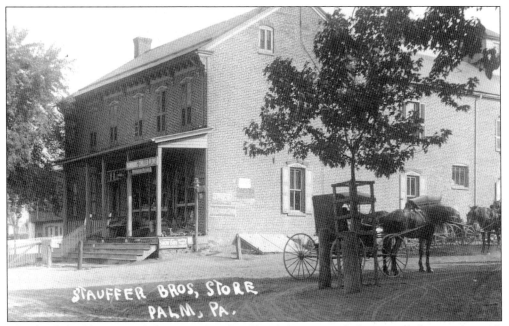

This brick building served the many needs of local farmers and also provided a storekeeper's residence on the second floor. Built about 1865, the Stauffer Brothers Palm Store and post office was an important part of community life for many years. The store sold a wide variety of groceries, farm implements, and veterinary medicines. In recent times, the building has served as a deli store, a post office, and private residences.

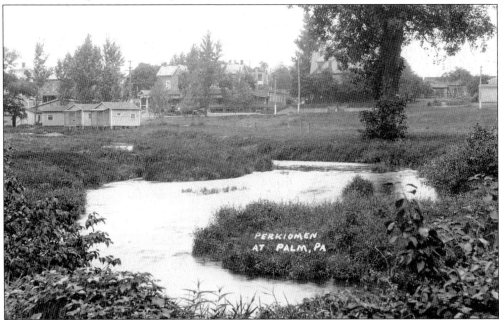

Flowing along the southwest side of the village of Palm, the Perkiomen Creek was not much larger than a brook. In this c. 1913 image are the cabins that were grouped in an area across Gravel Pike from the hotel. While the cabins contained no utilities, they were an opportunity to experience privacy and all the joys of roughing it along the creek.

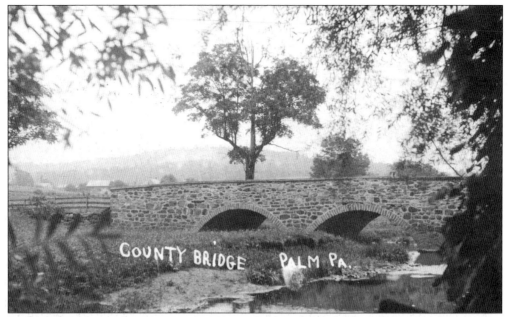

During the 19th century, Montgomery County built many multiple-arch stone bridges. Shown here is the county bridge built over the Perkiomen Creek along Palm Hill Road in the village of Palm. Built in 1898, it was one of the last of its type, since two years later the county plans changed to a preference for concrete bridges. While narrow by today's standards, this quaint bridge still serves local traffic.

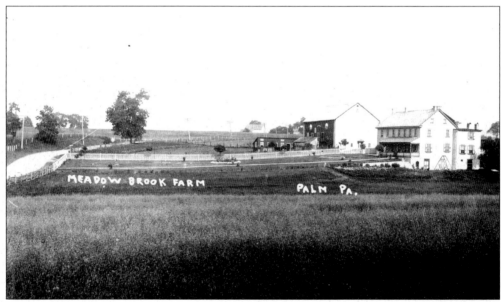

The Meadow Brook Farm was in its prime during the early 20th century, when it was owned by the Gery family. With white picket fences, manicured lawns, and garden beds, the farm displayed significant eye appeal to travelers along Gravel Pike in Palm. The present house bears a date stone inscribed 1748. Much of the acreage has been sold off over the years, but the tract still contains 103 acres. The John Wentz family owned the farm after 1950.

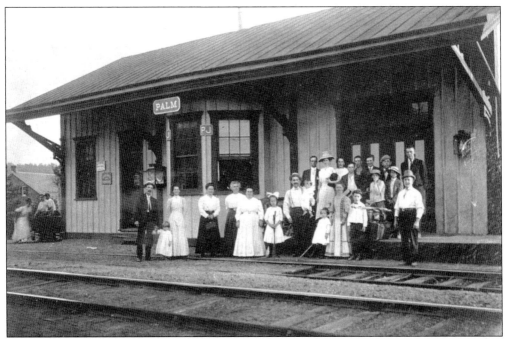

The Palm railroad station, shown here around 1910, was a short distance from the intersection of Gravel Pike and Station Road. Before the proliferation of automobiles, the railroad was a quick, clean, and comfortable way to visit family and friends who might be situated along the line of the railroad. Besides passenger service, the Palm station did a brisk business in the shipment of local agricultural products. Until 1925, the Palm depot was one of the most active shippers of milk in cans on the Perkiomen rail line.

The Perkiomen railroad tracks made a diagonal crossing over Gravel Pike south of Palm. In this postcard view taken about 1914, a southbound line of cars passes over this still-familiar rail bridge. A careful inspection of this image will reveal a man standing under the newly installed telephone wires that were strung under the bridge at the time.

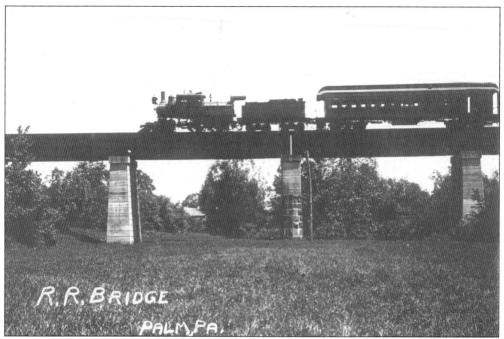

Above is an artistic silhouette view of an early-style locomotive pulling cars over a railroad bridge near Palm around 1906. The c. 1905 scene below is that of a wooden trestle in front of the railroad bridge over the Hosensack Creek, a short distance south of the Palm station. The railroad's many bridges and trestles provided scenic pleasures, but they were a real headache for the rail company's maintenance and safety crews. The route north of Palm was one of the most troublesome, with curves and grade increases, in addition to some of the highest and longest trestles. In 1907, the railroad decided to remedy the situation. Great amounts of earth were brought in, and many of the old wooden trestles were filled in and eliminated.

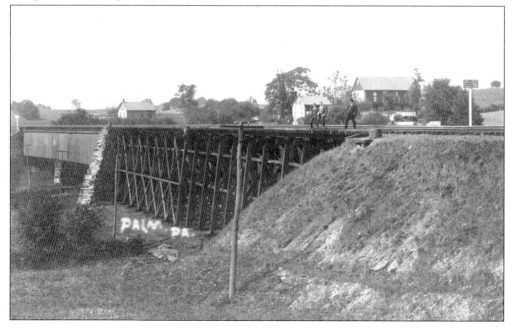

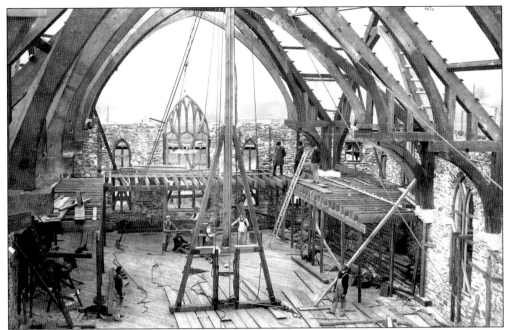

In the beginning of the 20th century, the Upper Perkiomen Valley Schwenkfelders had meetinghouses at Kraussdale, Hosensack, and Washington. It soon became necessary to acquire more space for the growing church school classes, so in 1910, the cornerstone for a new church was laid at a site on Gravel Pike in Palm. The Palm location was thought to be a central location, and the plan was to discontinue worship at the meetinghouses. In the view above, workers erect wooden structural members and lay the local stone walls. Below is a view of the nearly completed church, which was dedicated on September 24, 1911. Subsequent to the completion of the original building, there have been several additions and improvements. The Palm Church now has members coming from the four surrounding counties of Montgomery, Berks, Lehigh, and Bucks.

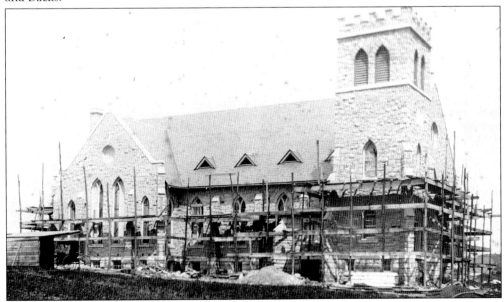

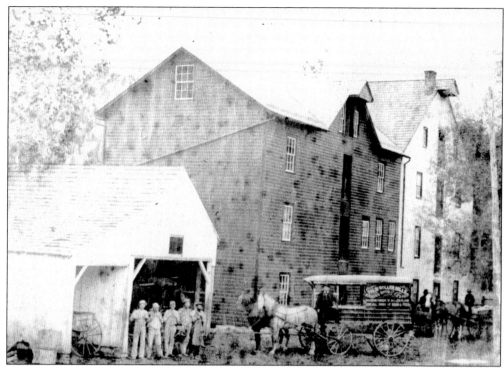

The photograph above was recorded in 1886. At that time the Palm Roller Mill was a gristmill operation of large proportions. The facilities consisted of several structures, which included a large frame building adjacent to a large stone building. In 1888, a fire destroyed the property. Later the stone mill building was rebuilt and is shown below as depicted on a postcard from around 1906. Over the years, the mill had been run by the Gerhards and later the Krauss family. In 1915, the rolling mill was still being operated by owner Lou Leibert. By 1923 the property was converted into the Millside Park by Harvey Heck and William Conway.

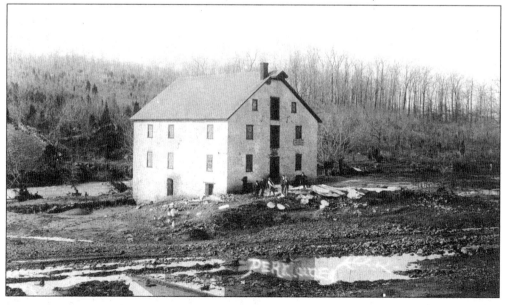

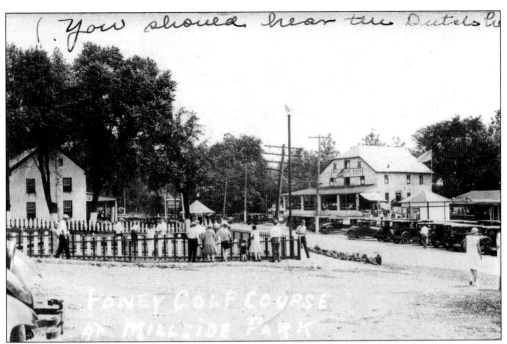

In the above 1920s postcard image is the main building and Pony Golf Course at Millside Park. The old converted mill shown here was a multipurpose building that served as a dance hall and bathhouse. People flocked to the park by train and private automobile during the busy tourist season. Attractions included many different games, rides, and water sports. The park also hosted special events, which included parachute landings and beauty contests. The image below shows one of the most popular activities. The waterslide with a wheeled carriage carried riders down a long slide and deposited them into the Perkiomen Creek. Although the park operated until the World War II period, it had many challenges over the years. In 1925, a violent thunderstorm flooded the park and a bolt of lightning almost destroyed the dance hall. Severe flooding again in 1935, 1937, and again in 1942 were too much, and this popular park met its watery demise.

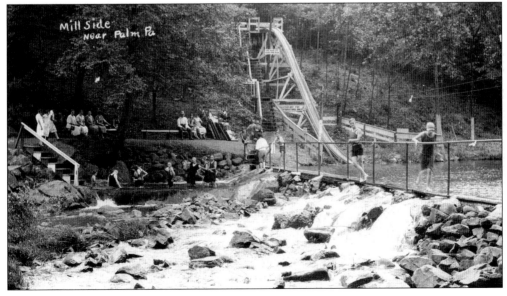

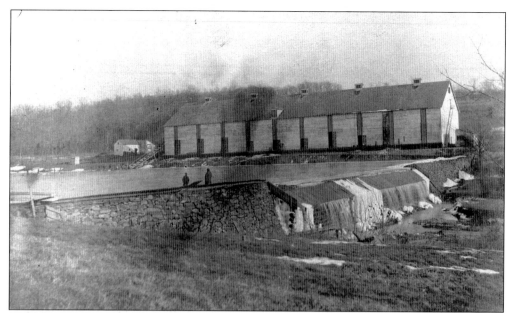

In 1896, the John Hancock Ice Company erected a dam and icehouse on the Hosensack Creek, near its junction with the Perkiomen Creek at Palm. At 311 feet long by 90 feet wide, this was one of the larger icehouses in the area. The storage rooms in the icehouse held stacks of ice that were 32 feet high. This large ice business operation contributed significantly to the local Palm economy by providing good wages for workers.

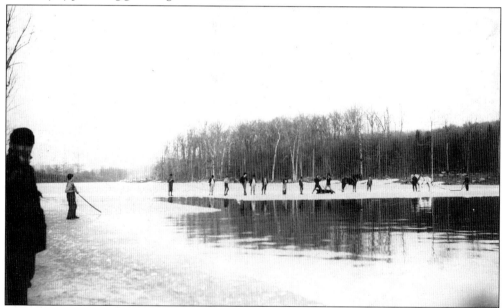

In this early-1900s photograph, workers and horses are seen at the John Hancock Company ice dam. The harvesting of ice required specific types of equipment, hand tools, and well-developed procedures for efficiency. After removing the snow from the surface, the ice was first laid out and scored by hand tools to produce blocks that would be about 28 inches square. Next a horse-drawn plow would cut grooves to a depth of about eight inches, assuming an average crop thickness of about nine inches.

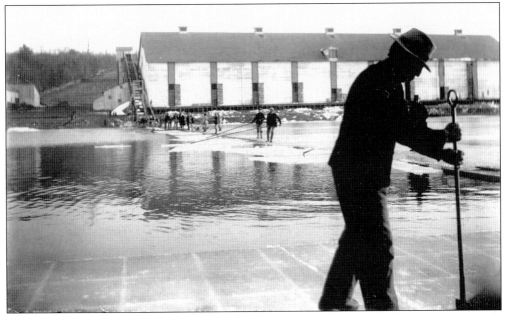

Ice workers put in long days during the harvest. They generally worked from dawn until dusk and sometimes until midnight, if there was a full moon. Here a worker uses a hand tool on the laid out ice blocks. Once the blocks were laid out and cut to a deep depth, a pinch bar or saw was used to break off an ice floe that typically would be about 4 blocks wide by 20 to 30 blocks long. A worker would then ride the ice floe out of the field and up to the channel that led to the icehouse. In most cases, a pole was used to propel the floe.

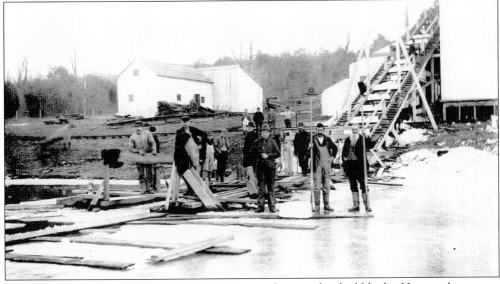

As an ice floe reached the icehouse, it was separated into individual blocks. Here workers pause briefly while feeding blocks into the inclined plane conveyor that would lift them to the storage level in the icehouse. At the top of the endless chain, blocks were generally fed through an ice planer that would shave off a top layer and make the blocks of uniform thickness for neat storage. Men then guided the blocks to their final storage place by sliding them on long hardwood runners inside the ice rooms.

In 1912, a little girl braces to take a photograph near the Perkiomen Creek at the picturesque footbridge located in Palm. The much photographed and famous footbridge was built across the Perkiomen just above the point where the Hosensack Creek flows into the Perkiomen. In the late 19th and early 20th centuries, this long-lived and sturdy structure provided daily convenience to many Palm area folks. Unfortunately, it washed away a long time ago.

In 1906, the young man in this photograph may not have felt that he was sitting on top of the world, but he was sitting at the highest elevation in Montgomery County. At 700 feet above sea level, Mill Hill is part of the Hosensack Hills, which straddle Montgomery and Lehigh Counties. Geologists estimate that the granite rock in this hill was formed about 150 million years ago.

Eight
BERKS, LEHIGH, AND BUCKS COUNTIES

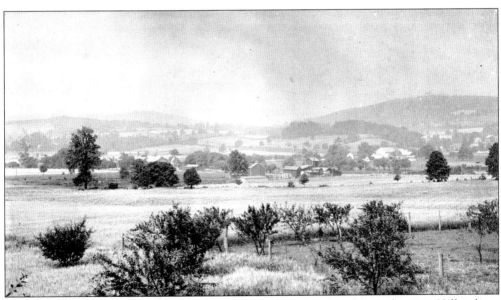

For the purposes of this book, the northern limits of the Upper Perkiomen Valley have been defined to include areas in Berks, Lehigh, and Bucks Counties that lie just beyond the Montgomery County lines. A limited number of selected villages around the headwaters and feeder streams to the Perkiomen Creek will be focused on. In this view, the beautiful and scenic rambling hills and valleys of southeastern Berks County appear as they were during the early 20th century. The group of buildings near the center of this view at Hereford is the farm and butcher shop of A. G. Kriebel. This property, which was located along old Route 100, was one of several Hereford properties that were owned by various members of the Kriebel family.

Around the 1850s, John Hillegas built a brick store across the street from his hotel in Herefordville. Numerous merchants such as tinsmith Benjamin Deysher were able to conduct business in the general merchandise store. Later the village became known as Chapel. When this c. 1908 postcard image was taken, George W. Welker, seen here standing second from left, operated the Chapel Post Office and store.

On November 16, 1908, the first snowfall of the year blanketed Chapel. The photographer was looking north on the Green Lane and Goshenhoppen Turnpike (Gravel Pike) when he captured this event. The home on the left is that of James Sallade. The first building on the right is a lumber shed, and the second building is that of Wagner's blacksmith shop.

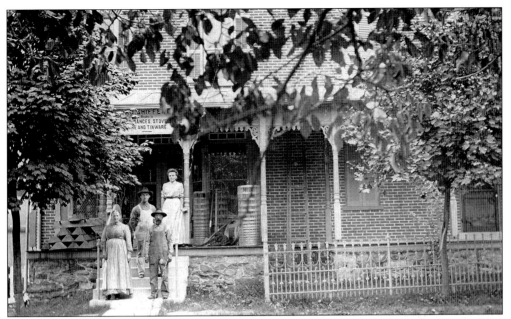

This brick Victorian store and residence was erected in 1894 by John D. Shiffert. Three generations of Shiffert tinsmiths conducted business at the corner of the Green Lane and Goshenhoppen Turnpike (Gravel Pike) and Shiffert Road in Chapel. John D. Shiffert and his wife are on the bottom step about 1910. Their son Edwin J. Shiffert and his wife are behind them. Today the building is a private residence.

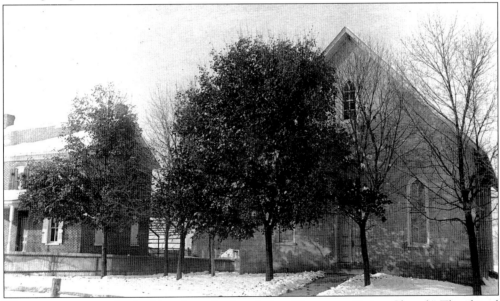

The cornerstone on this building bore the inscription "Protestant Union Chapel." The chapel was erected in 1889 along the Green Lane and Goshenhoppen Turnpike (Gravel Pike) at the upper end of the village of Chapel. The chapel was built to augment other area churches at a time when a convenient place for evening worship was needed by locals. Until about 1920, Sunday evening services were conducted in German. After many years, evening services were discontinued, and the building was later razed in 1953.

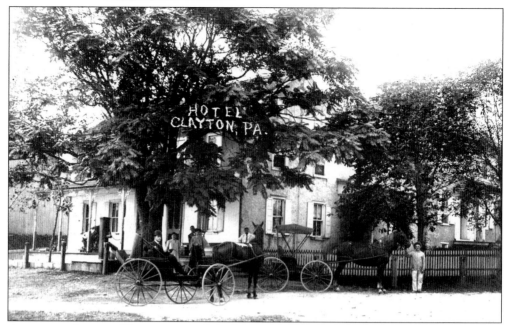

A tavern and inn at Clayton was built by Jacob Treichler in 1839. He also kept a small store in the building. After his death, the business was conducted by his widow, and then there was a succession of different owners. This postcard image from 1909 shows a summer view of the old hotel. The horses and carriages are standing on the old Clayton to Bally Road, which ran alongside the hotel.

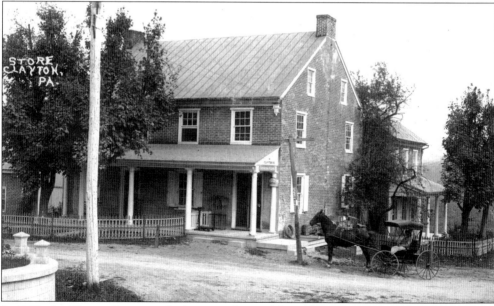

In 1856, the Clayton Store was built across the road from the Clayton Hotel by John Bechtel. Along with his son A. B. Bechtel, he engaged in merchandising. The property later came under the ownership of the Schultz family, which also operated a post office here. The store is shown around 1908, when proprietor Henry H. Schultz was popular for conducting public sales of cattle at his nearby stables.

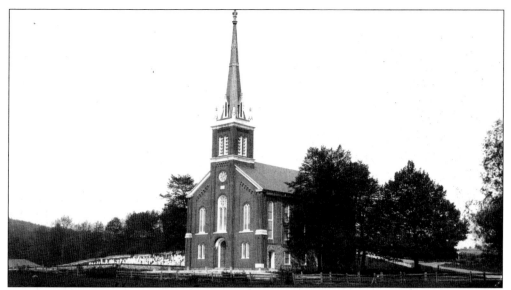

The first Huff's Union Church was erected in 1814 on land donated by the Huff family. The church was located near the headwaters of the west branch of the Perkiomen Creek at the eastern corner of Berks County. A village formed around the Huff family's public house. The village later included a post office and various mechanics and merchants' stores. In this image recorded around 1900, one can see the second and current church building erected in 1881 in the village named Huffs Church.

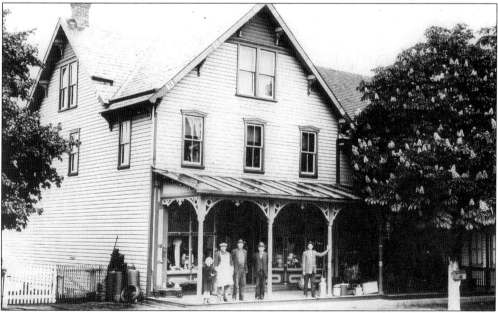

Huffs Church General Store and post office was located on Huff's Church Road, the main road through this small village. During the period from 1876 until about 1920, the store was run by the Daniel R. Bechtel family. The store is shown here during the later years of their tenure. With the death of Daniel in 1915, Sally Ann, his wife, continued the business until she sold it in 1920 to the Howard S. Pilgert family. The Pilgert family continued the business until 1985. This building is now an antique shop and bed-and-breakfast.

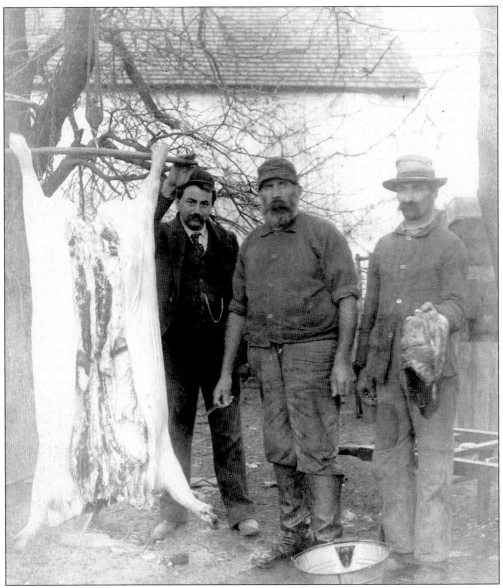

This photograph was recorded near Hereford sometime between 1900 and 1905. Since pork was far and away the favorite meat of local folks, the butchering of a hog was a common activity on many farms and all butcher shops. The importance of this image is due to the well-dressed gentleman standing on the left. H. Winslow Fegley (1871–1944) lived in Hereford until 1905, when he moved to Reading. He was a businessman who ran a local country store. More importantly, he was a serious photographer. Many of the photographs in this book are a result of his enthusiastic passion for Pennsylvania German life. The large collection of his photographs was received by the Schwenkfelder Library in Pennsburg soon after his death. The collection is a wellspring of images and information about early-20th-century life in the Upper Perkiomen Valley.

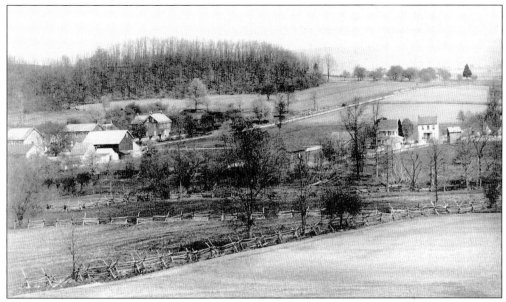

About 1900, this postcard image was photographed and later published by H. Winslow Fegley. He labeled this image with the caption "Junction of the Perkiomen and Butter Valleys, Hereford Township, Berks County, Pa." The photograph actually shows Fegley's house, which was the large brick house on the right on the upper road. This was one of the most popular postcards published by Fegley and was sold for decades.

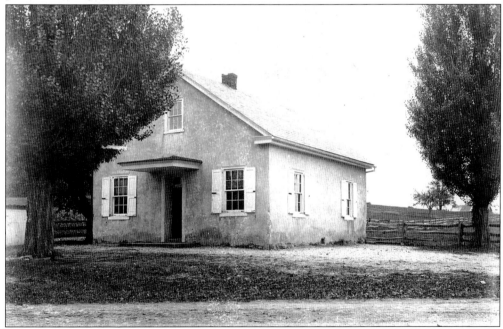

In 1903, H. Winslow Fegley used his photograph of the Hereford school on an advertising calendar for his store. Shown here, the school was officially known as the Treichlersville School. By the 1911–1912 school year, the school was being officially referred to as the Hereford School. Thus, the village name change from Treichlersville to Hereford seems to have transitioned during this period of time. Today the modified schoolhouse is being used as living quarters.

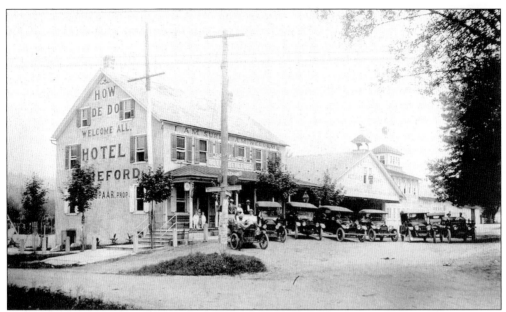

The Hereford Hotel was built in the 1830s by Sam Treichler and in the early years was known as the Treichler Hotel and the Sand Springs Hotel. In 1902, it became Hoffman's Hotel. At the time it was a well-known sale location where cattle, horses, and other livestock were traded regularly. In 1912, the hotel came under the ownership of Augustus D. Spaar, who was an aggressive promoter. It is shown here a few years after Spaar had improved and expanded the business.

In this view, a sale is being conducted at the Hereford Hotel, which proprietor Spaar also referred to as the Junction House Hotel. The later reference is due to its excellent location at what is now the junction of Route 100 and Gravel Pike. For about four decades, the hotel prospered under Spaar's leadership. He added an antique museum and sponsored all kinds of special events. Presently the main building operates as a tavern and restaurant, and the stable and other outbuildings have been removed.

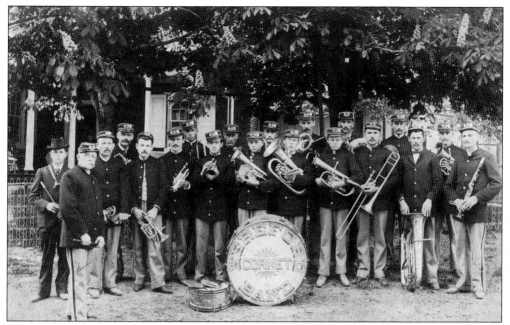

Historical records are not clear regarding the organizational date of the Hereford Coronet Band. Photographic records such as this image from roughly the early 20th century indicate that the band was well equipped and played at many local events. Standing in front on the left side is Henry K. Urffer, who was the band director at the time. When not playing with the band, Urffer was known to be involved in the building of church organs.

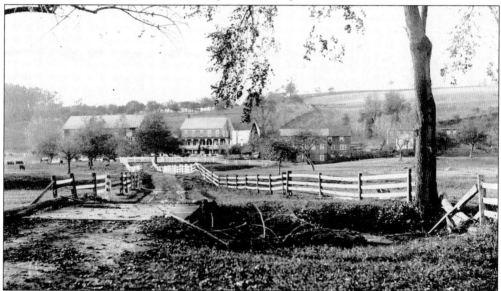

Located on the northeast side of Hereford, this classic farm and homestead originally consisted of 223 acres of land. It has been owned by many generations of the Schultz family. Daniel S. Schultz was the fifth-generation owner who developed the tract during the mid-19th century. He died in 1886, and the homestead passed to his wife, Mary, in 1897. This image was recorded soon after that time. By the 1980s, all the farm buildings had been removed. In 2007, the property was still owned by the Schultz family.

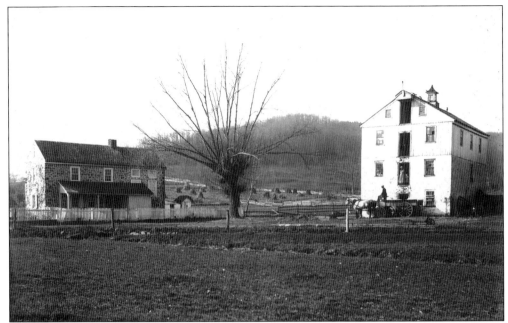

This mill stood on the west bank of the Perkiomen Creek near Hereford. When this photograph was recorded around 1903, the mill and farm property had been in the Treichler family for three generations. The mill was being run by a teenage girl. Sally R. Treichler, daughter of proprietor David G. Treichler, was completely in charge of mill operations. Sally, "the Girl Miller," was surely one of the youngest females in the trade. The mill building (right) was razed in 1978. The house (left) is still standing.

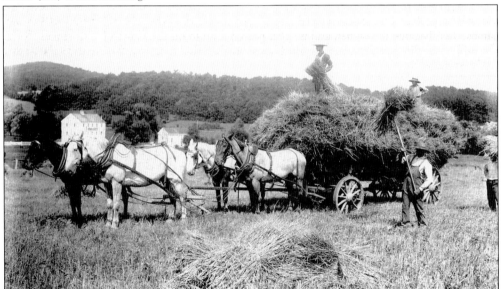

With the mill in the background, a common harvesting activity on the Treichler farm near Hereford is seen. A crew of four farm hands is busily engaged in loading sheaves of grain onto the wagon. This was hard and exacting work. The two men on the ground, working with pitchforks, had the arduous job of gathering and lifting the sheaves up to the wagon. The people on the wagon had to arrange the sheaves carefully in order to avoid damage or loss of the grain.

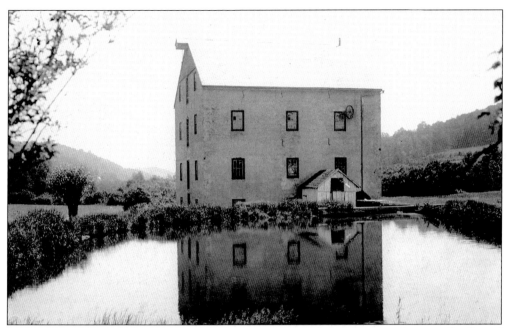

In the above early-20th-century photograph is a nostalgic view of Christman's gristmill reflected in the placid waters of the millpond. The image below shows the miller's house as it existed at the same time. Located northwest of the village of Hereford, where the Perkiomen Creek crosses Weaver Road, the mill was operated by the Christman family for more than a century. When the mill property was first purchased by Philip Christman in 1801, both the mill and the house were of log construction. In 1850, Philip's grandson Jacob tore down the old log cabin, and in 1857, he razed the old log mill. They were replaced by the stone structures pictured here. On Good Friday, March 30, 1866, Jacob fell out of the upper door of the mill and was killed. His son, James, then became the owner, and he later passed it on to his son Calvin J. Christman. Today the mill is standing idle, and the occupied house has had the stucco removed to show the beauty of the stone walls.

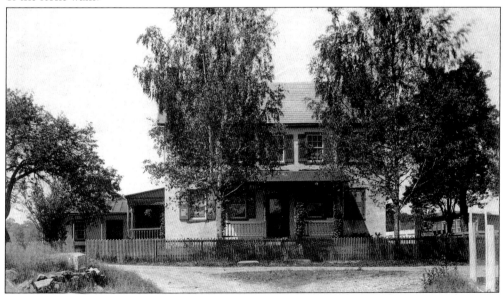

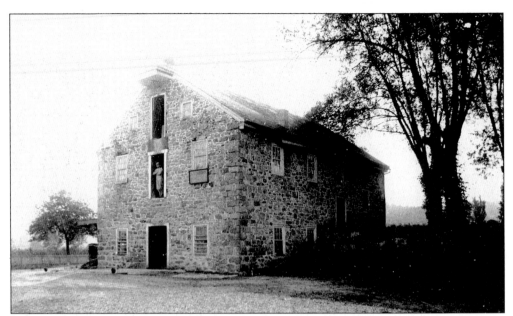

In 1837, Israel Kriebel built a mill on the main branch of the Perkiomen Creek. The mill was operated for decades by various members of the Kriebel family who also branched out into various agricultural activities in the Hereford area. In this c. 1910 view of the gristmill, Lewis Kriebel stands in the doorway of the second level. Milling operations ceased in 1935, and later the building received significant modifications. It is now occupied as a residence at the corner of Kriebel Road and Route 100.

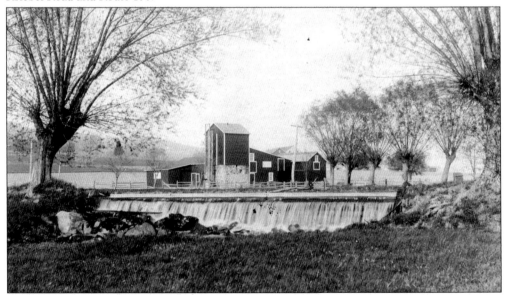

Here is the breast of the dam at Kriebel's mill. The dam stored water from the Perkiomen Creek to operate the mill. Andrew G. Kriebel's butcher shop is in the background across Route 100, which ran between the dam and the butcher shop. The tall building at the center was the icehouse used to store ice for the refrigeration of meat in the warmer months. The butcher shop operation flourished for decades but is no longer in business. The buildings are now the site of a thrift shop.

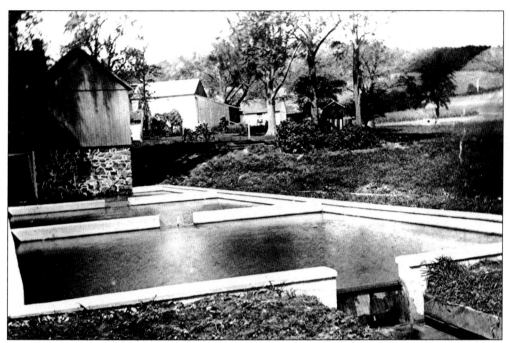

A century ago there were many different types of farms operating in the Upper Perkiomen Valley. The Calvin G. Kriebel farm engaged in the practice of fish farming. The raising and selling of fish on a commercial basis was unusual for the area; it required specially designed ponds, as seen in this view along Kriebel Road in Hereford. The farm is no longer operating, but portions of the fish pond and the surrounding buildings are still standing.

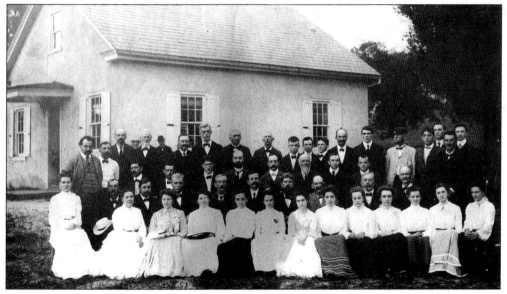

The Hereford Debating Club had its birth in 1875, when three public school teachers tried to determine whether Christopher Columbus deserved more honor for discovering America or whether George Washington deserved more credit for defending it. By 1878, the group met on a regular basis and the name was changed to the Hereford Literary Society. A portion of the debating society is shown here around 1903, when membership reached 250 debaters.

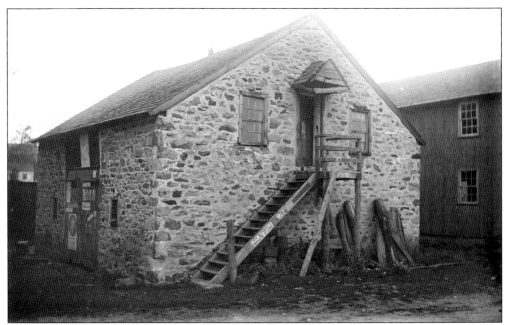

The village of Harlem is just northwest of Hereford. This stable was built across the road from the Harlem Hotel about 1803. Shown here about a century later, it was typical of many stone or wooden structures that were part of almost every village in the Upper Perkiomen Valley. The ground floor was used as a stable for the protection of horses. The second floor was frequently used for public meetings, dances, or other social events. This particular building was a regular meeting place of the Hereford Literary Society.

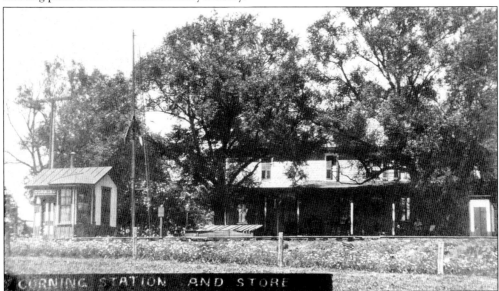

The small village of Corning is located at the southern end of the Powder Valley in Lehigh County. With the coming of the Perkiomen Railroad, a small station house was built at Corning in the late 1870s. In 1883, a post office and store was opened nearby. Here are these two structures as they appeared in the early 1900s. The station house is long gone, but the store building is still standing as a residential property.

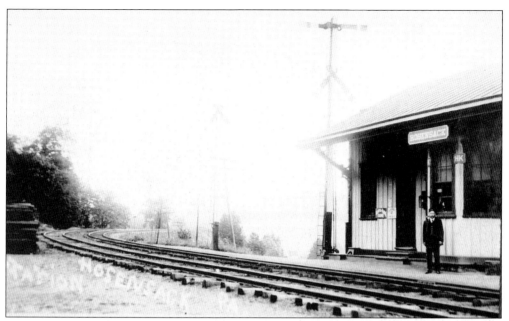

For rail travelers heading north, the next stop after Corning was the Hosensack Station, shown here in the early 1900s. History books never did record exactly how or who gave the village this moniker. It is known that the word literally translated from the old common Germanic dialect means "trousers pocket."

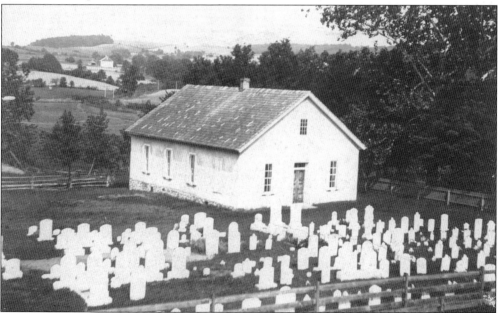

Shown above, the Schwenkfelder's Hosensack meetinghouse and cemetery is located east of Palm along Hosensack Road near the line dividing Lehigh and Montgomery Counties. The size and design of this structure is nearly identical to the Schwenkfelder Washington meetinghouse, which was located on the line dividing Berks and Montgomery Counties near the village of Clayton. This Hosensack meetinghouse still stands; the Washington structure was razed after the completion of the Palm church in 1911.

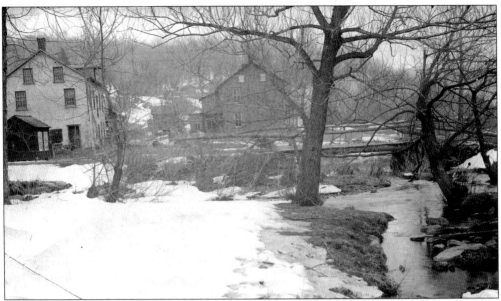

Situated in the bottom corner of Lehigh County, the Indian Creek was a fast-falling, swift-running tributary to the Perkiomen Creek. This Upper Milford Township creek was the place where many millers decided to set up shop. The village of Powder Valley was named for the powder mill erected there in the early 1800s. In this wintertime photograph are the Powder Valley Mill (left), the Powder Valley Store (center), and the Indian Creek (right) as they appeared in the early 1900s.

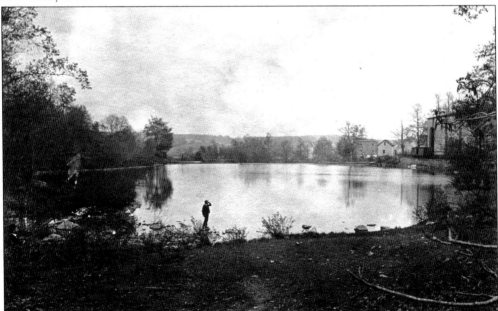

The John Hancock Company owned five of the seven dams built by the natural ice industry in the Upper Perkiomen Valley during the late 19th and early 20th centuries. This early-1900s photograph shows the small ice pond and icehouse (far right) built by the company on the Indian Creek at Powder Valley. Built in 1880, this Lehigh County dam marked the most northern reach of expansion up the Perkiomen Creek for the company.

Pictured here in 1908 is a log house that was believed to be the oldest house in the Upper Perkiomen Valley at that time. It was the first two-story Schwenkfelder house and was built about 1735 by Balthasar Krauss. Indications are that it was located along Warners School Road about one mile west of the village of Kraussdale. The structure later fell into a state of disrepair and was torn down about 1919.

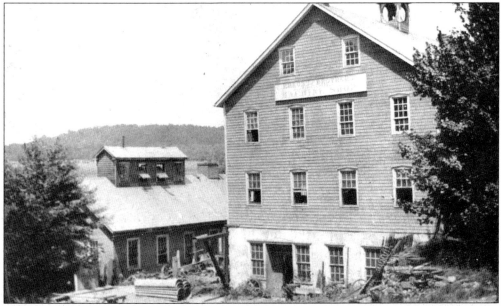

During the 19th century, many generations of the Krauss family of Kraussdale exhibited their high skills and artisanship in the design and building of machinery. In the early 1800s, John Krauss made wool-carding machines. Later his son, Anthony, expanded the business into threshing machines. After 1852, Anthony's sons Isaac, Harrison, and James made all kinds of farming implements under the name of Krauss Brothers Machine Shop. This image of the Krauss Brothers Machine Shop and sawmill was captured a short time before the business was discontinued here around 1900.

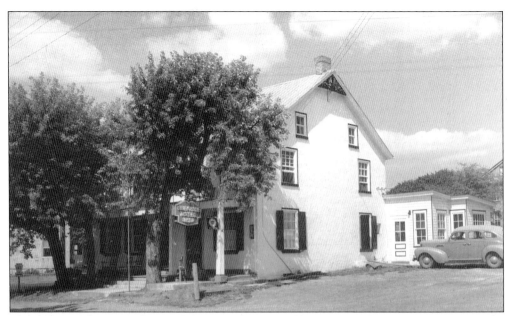

This image of the Geryville Hotel was recorded around 1940. Liquor licenses were issued to the Geryville Public House as early as 1745. During the early 1900s, the hotel was famous for its good meals and community events. The second floor of the adjacent barn was used for dances, shows, and other social events. The barn burned in 1949 and was not rebuilt. The Historic Geryville Public House has seen alterations, and it is still open for business along old Route 663.

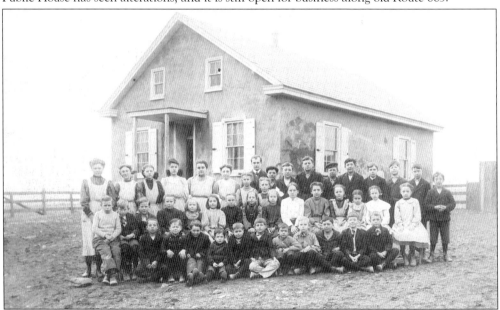

The Geryville School was built around 1850. Pictured in front of the school in this c. 1908 photograph is teacher Howard Linsenbigler (standing in back) with the entire class. At the time, the building had no electricity and heat was supplied by a potbelly stove. Students had to go across the street to a farmer's well for pails of water. A single dipper in the pail served all. In 1954, the school closed and was later used as a residence for a time before finally being razed in the spring of 1975.

This image shows the Finland store and post office at about the time that ownership passed from Henry K. to Harry S. Trumbauer. This post office was established along Upper Ridge Road near Trumbauersville Road in the tiny village of Finland in 1886. Henry K. Trumbauer operated the store and post office until his death in March 1910. His son, Harry, purchased the store from the estate in June 1912. In 1916, the post office was closed and service was picked up by Red Hill. The old store is currently a residence.

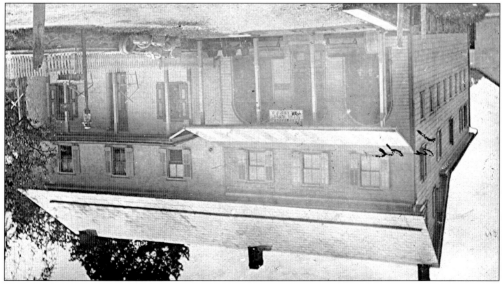

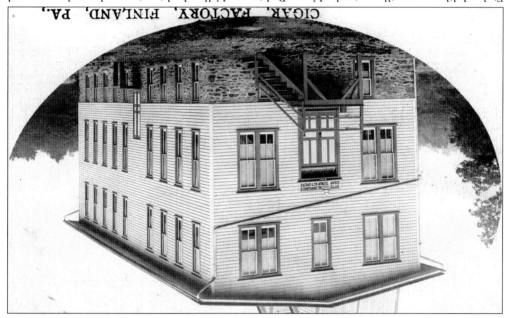

Finland, like many villages in the Upper Perkiomen Valley, had its cigar makers who operated out of their homes. With this in mind, the Finland Improvement Company was organized in order to erect this 32-by-60-foot structure. Shown here after its completion, the factory was erected in 1907 for the use by the Otto Eisenlohr Brothers Cigar Company. After the demise of the cigar industry, the building stood empty for years and later was used as a garage. It was razed in the early 1970s.

ACROSS AMERICA, PEOPLE ARE DISCOVERING
SOMETHING WONDERFUL. THEIR HERITAGE.

Arcadia Publishing is the leading local history publisher in the United States. With more than 3,000 titles in print and hundreds of new titles released every year, Arcadia has extensive specialized experience chronicling the history of communities and celebrating America's hidden stories, bringing to life the people, places, and events from the past. To discover the history of other communities across the nation, please visit:

www.arcadiapublishing.com

Customized search tools allow you to find regional history books about the town where you grew up, the cities where your friends and family live, the town where your parents met, or even that retirement spot you've been dreaming about.

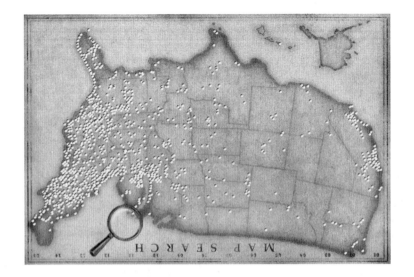